7/29/2003

To Matt –
Good memories of
East Lyme guaranteed!
Kathy Britos

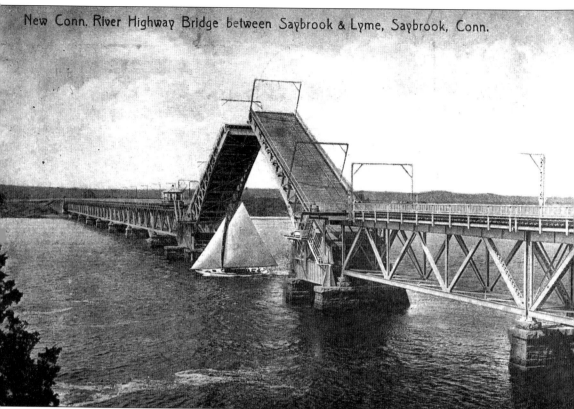

New Conn. River Highway Bridge between Saybrook & Lyme, Saybrook, Conn.

In 1911, a ferry service connected Old Lyme to Saybrook, the next town down the Connecticut coast. The building of a bridge, even a bridge that had only two lanes, changed everything. Today's bridge, the third one to cross the Connecticut River at this site, boasts eight lanes and is part of Interstate Route 95. It has changed the life of the river itself. Cars and trucks have replaced boats for commercial deliveries, and many vacationers cross the bridge to come to the area. East Lyme sits halfway between Boston and New York on Long Island Sound. The Lee, Griswold, Peck, Gardiner, Watrous, Avery, Sill, Manwaring, Beckwith, Chadwick, Turner, Marvin, Lord, Comstock, Sterling, DeWolfe, Caulkins, Hoskins, Ely, Tinker, Smith, Champion, Selden, Warner, Beebe, Brockway, Littlefield, Campion, Palmer, and Winthrop families are among those who first settled here in the 1600s.

Dedicated to Nicholas Stillwell, who came to Connecticut in 1638, and to my mother, Dorothy Stillwell, who would not let me forget it.

IMAGES
of America

EAST LYME

Kathryn Burton

ARCADIA

First printed in 2003.

Published by Arcadia Publishing,
an imprint of Tempus Publishing Inc.
2A Cumberland Street
Charleston, SC 29401

Printed in Great Britain.

Library of Congress Catalog Card Number: 2003101275

For all general information, contact Arcadia Publishing:
Telephone 843-853-2070
Fax 843-853-0044
E-mail sales@arcadiapublishing.com

For customer service and orders:
Toll-free 1-888-313-2665

Visit us on the Internet at www.arcadiapublishing.com.

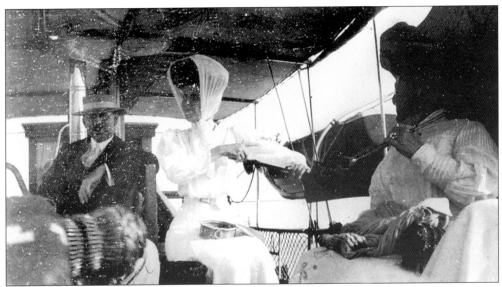

These three people are certainly not out to get a suntan. Shaded from the sun by hats, scarves, a parasol, and an overhead canopy, they gaze out at the passing scene.

CONTENTS

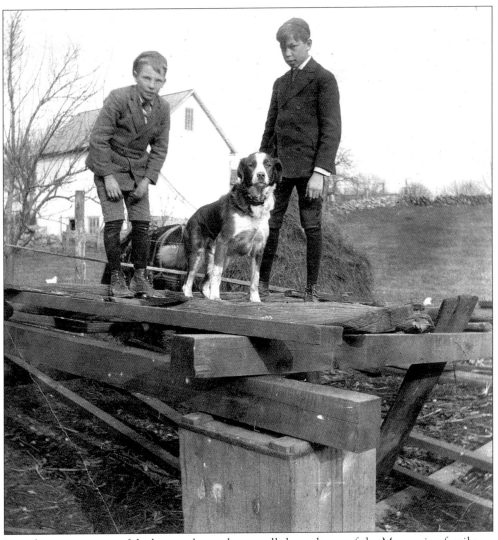

Poised atop some sort of dock are a dog and two well-dressed sons of the Manwaring family.

INTRODUCTION

Although the Dutch were the first to engage in fur trading at the mouth of the Connecticut River, they were outnumbered in the area by the English. This fact and their further explorations convinced the Dutch to move inland toward the Albany area. Thus, they relinquished to the English, without incident, what were to become Saybrook and other Connecticut Valley settlements.

In 1639, the Earl of Warwick granted the land between Narragansett Bay and the Connecticut River to Viscount Say and Sele and to Lord Brooke. These men were English Puritans with great wealth, aspirations, and the need for a safe harbor should the political situation in England worsen. Plans were made to build a fort in this area of the New World. Charter subscribers would be housed securely and in comfort, as gentlemen, with their families, under the protection of Gov. John Winthrop Jr., son of the Massachusetts governor. Lion Gardner was commissioned to design and build a fort in Saybrook at the mouth of the Connecticut River, where it enters Long Island Sound, which proved to be a vital place during the Pequot Wars. The settlement commanded both sides of the river: Saybrook on the western side, and East Saybrook (what would become Lyme, Old Lyme, East Lyme, and Hadlyme) on the eastern side.

George Fenwick traveled from England to oversee the new settlement. As the situation in England became less threatening politically, the fort was not quite so vital and its backers withdrew. In 1644, Fenwick sold the area to Connecticut. A year later his wife, Lady Fenwick, died. Fenwick returned to England, leaving the protection of his wife's tomb to Matthew Griswold, who received a tract of land on the east side of the river in payment for this service. Griswold named this tract of land Lyme, after the place of his birth in England, Lyme Regis. The Griswold family's importance in the area continues to this day.

Prior to English settlement and for more than 300 years afterward, there were peaceful Native American groups in East Lyme, especially the Nehantics, from which the town of Niantic took its name. The languages of these Native Americans are reflected in the names of local rivers, roads, and natural features, such as Oswegatchie Hills. The early relationship between the settlers and the Nehantics was neighborly. From the English settlers, the friendly Nehantics gained protection from other inland Native Americans who had previously waged war against them, both here and on Long Island. Over the years, many Nehantics went to upstate New York. Land was put aside for reservations, which were used until the last acreage was auctioned off on June 1, 1867, and most of the remaining Nehantics had moved west.

In 1668, Lyme became a town comprising Old Lyme to the south, Lyme itself, Hadlyme to the north, and East Lyme. From the beginning, earning a living in the Lymes was difficult for the settlers. More stones than produce came from the farmers' fields. However, there was coastal access for trade, some of it part of the West Indies triangle trade. Ultimately, some farms yielded to failure. Later, some of the native stone proved to be valuable and was quarried.

During the American Revolutionary War, Gov. Jonathan Trumbull served as commissary general of the Continental army. Connecticut supplied vast amounts of needed items and served as a regional supply depot for Gen. George Washington's army. In April 1775, a large company of men from the Lyme area went to Cambridge, Massachusetts, to join in the defense of Boston. One month later, there were 3,600 men from Connecticut in the Colonial militia. Connecticut men fought at the battle of Fort Ticonderoga and under Gen. Israel Putnam at Bunker Hill, and they commanded many privateer vessels, seeking out hundreds of British ships along the Atlantic coast.

In 1781, Benedict Arnold, a native son but an English sympathizer, burned the nearby town of New London. His men killed Capt. William Ledyard and 80 of his men. The fate of the traitor Arnold is well known. After the American Revolutionary War, a number of young people from the area went west to settle the land there that was still owned by Connecticut prior to the Northwest Ordinance. Moses Cleavland and Moses Warren, two surveyors from East Lyme, were later honored by having Ohio cities and counties named after them. Warren, who became a judge and held many other public offices, played an important role in working with the Nehantics. His original home, located on Boston Post Road in Flanders, was known as the Red House.

The Lymes survived and assisted in the recovery of their inland neighbors, despite continuing aggression by the English that ultimately brought on the War of 1812. After that, a short respite was followed by the Civil War, which had a major impact on local shipbuilders, who were still engaged in producing wooden ships at a time when iron ships first came on the scene. Iron ships proved to be sturdier when under attack and helped make wooden ships obsolete. The last wooden ship was made in the area in 1861 at the Beckwith shipyard at the head of the Niantic River.

The ill-fated vessel *Niantic*, built in Chatham (East Hampton) in 1835, had a short but exciting life. The ship took part in whaling excursions in the Pacific Ocean and in carrying men to seek their fortunes at the 1849 gold rush camps in California, before it burned in 1851. An earthquake destroyed the small hotel that was built from the remnants of its hull, putting it finally to its rest, a continent away from home.

Now, we enter the age of photography.

One
LIVING HISTORY

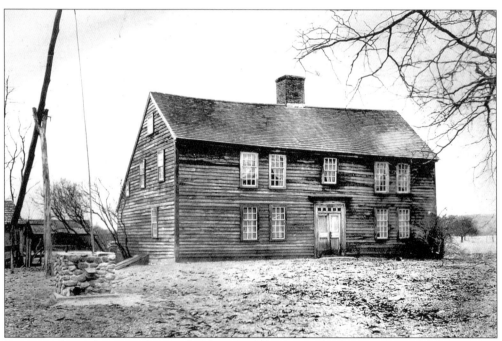

For more than 250 years, the Lee family owned this house, built on Shore Road (now Route 156) in East Lyme. Young Thomas Lee Jr. had lost his father, Thomas Lee Sr., and his grandmother to smallpox on the voyage from England. His mother raised the children with the help of her father and friends. The Lees became a successful family, and its members went on to hold many public offices. It has been calculated that over a 200-year period, members of the extended Lee family built some 200 miles of stone walls surrounding homes and barns in towns as far away as Salem.

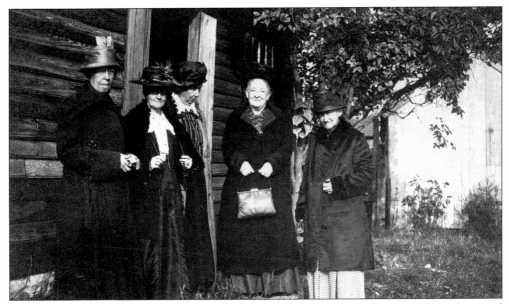

The Thomas Lee House was in danger of being torn down, but a small group of people joined forces with local and national preservation groups to save it. The house is preserved today under the care of the East Lyme Historical Society.

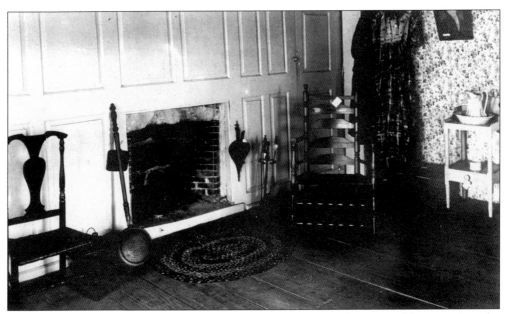

The original structure of the Lee House remains intact and has been noted by experts in the field as a very fine representation of an early period in Colonial architecture. Its simplicity of line and sureness of purpose has been copied by many modern architects and builders seeking to recapture the authentic look.

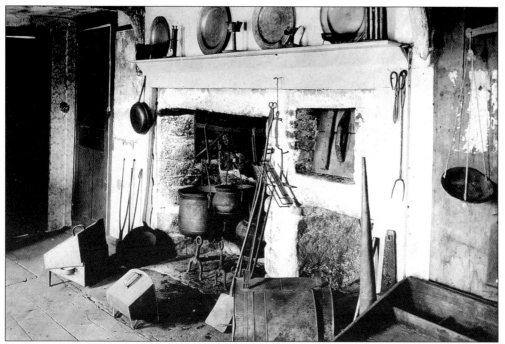

The Thomas Lee House is listed on the National Register of Historic Places and is now in the care of the East Lyme Historical Society, which operates it as a museum.

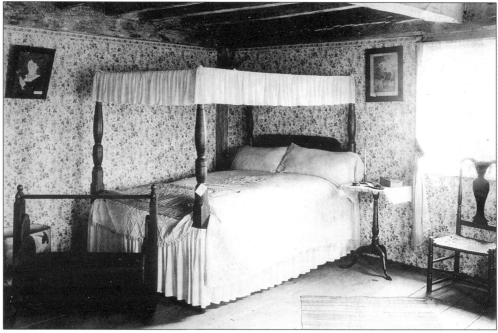

When one looks at the Lee House, thoughts of harsh weather, loneliness, and hardship are sure to come to mind. Of course, Thomas Lee Jr. and his wife were not lonely. Together they had 15 children.

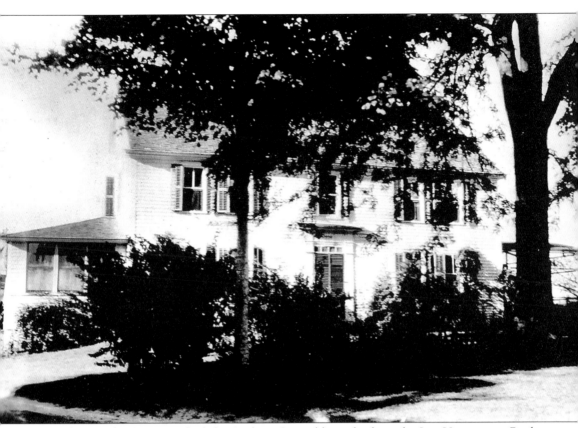

Bride's Brook Manor was built by Andrew Griswold not far from the Lee House, near Rocky Neck. Fortunately, this photograph exists, as the house was torn down many years ago.

In 1672, a young man named Jonathan Rudd was to be married. The ceremony could not take place because of a great snowfall that kept participants from attending. Gov. John Winthrop traveled to Bride's Brook and married Rudd and his bride, changing the western boundary of Massachusetts and taking in Black Point and Giant's Neck, which had been granted to the Griswolds and Thomas Lee.

While the Smiths and Harrises were alive, their farm was called Brookside. The house was built in 1845 by Thomas Avery, a farmer and salesman who died in 1869, leaving it to his son. Avery's widow sold it to William H.H. Smith, who used the property as a summer residence. It was managed by Smith's younger brother Herman Smith and his nephew Frank Harris. The men married the Munger sisters of Niantic c. 1900 and shared the house and 103 acres of work for more than 60 years.

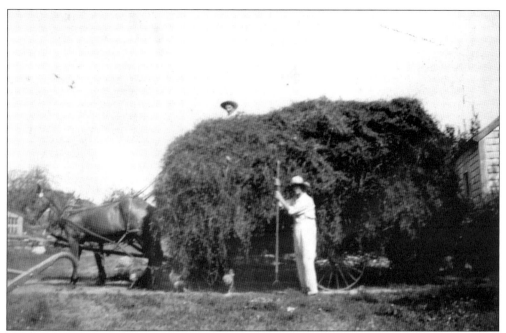

A season's work is now finished in the hay fields—by hand. As they aged, the men used a tractor at Brookside, but they worked the earth until their end.

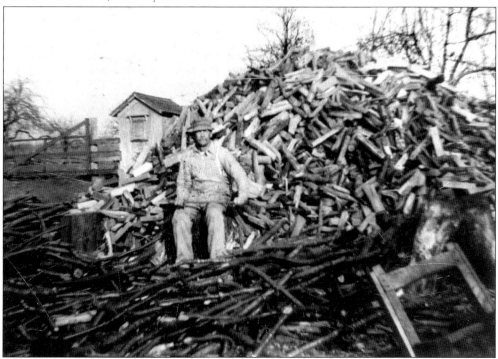

Herman Smith is shown sitting on a pile of wood. Those who knew the two families as kind, thoughtful, hard-working people wanted to preserve Brookside after the last of the last surviving member, Florence, died in 1973. Purchased by the town in 1955, the property was dedicated as a museum area on July 3, 1976, at the time of the U.S. bicentennial.

The Brookside barn and apple trees are a lovely sight. The farm's flower and vegetable gardens were also beautiful and productive, but very hard work. Members of the Friends of the Smith-Harris House are currently working to restore more of the farm and garden areas.

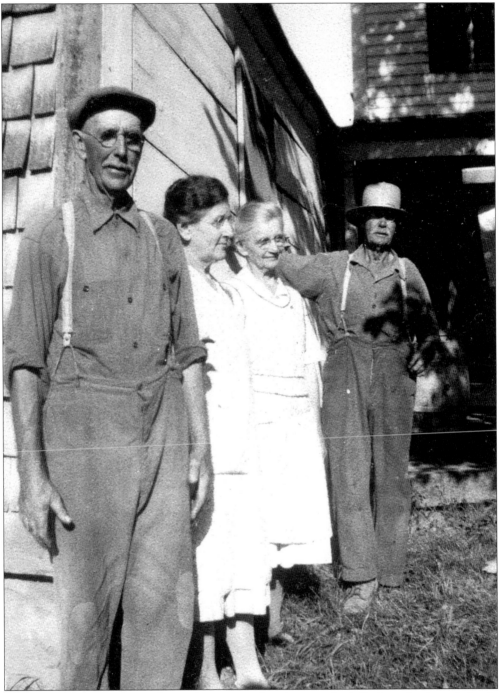

The Smiths and Harrises reluctantly agree to be photographed. Rather shy but obviously good-natured people, they were beloved by many in the community.

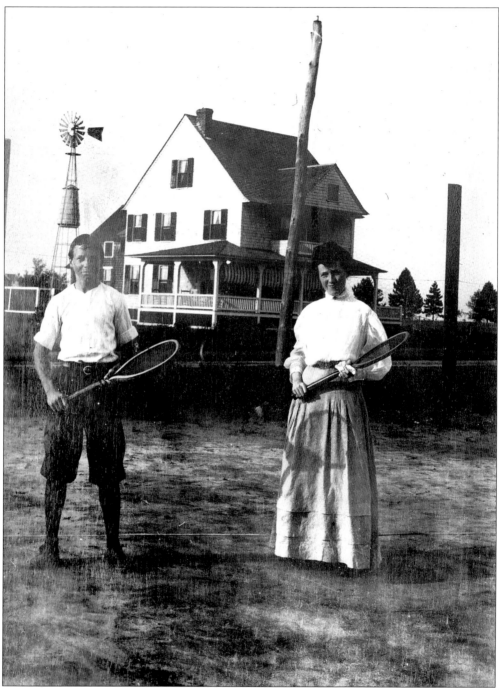

Old Black Point was granted to the Gorton and Payne families at an early date. The name Black Point was given to the area by mariners who knew the danger of the rocky ledge sitting just below the surface of the Atlantic Ocean, giving the water a jet-black appearance. The development of Black Point began in the 1880s, and the area became known as Dutch City because of the number of windmills that brought water up from residents' wells. Shown are Martin Scovill and his tennis partner.

These photographs depict a typical summer at Old Black Point from the viewpoint of a single family, Judge Charles C. Nott's. However, the view is one that was shared by many from the 1880s onward. Neighbors got together for social events, sports, and children's activities. It was great fun.

Old Black Point was especially wonderful for children, who spent the entire summer season swimming, sailing, playing tennis, and dancing in a place they would never forget and would return to whenever possible.

Just as other areas developed their own personalities and characteristics, Old Black Point developed its own. Black Point was comparatively much more private and less connected to the town. Its residents lived in a quite different style, and they liked it that way. At one time, the largest flock of sheep in Connecticut was to be found on Old Black Point. Writers have captured that era, and designers have tried to duplicate it, but this was the real thing.

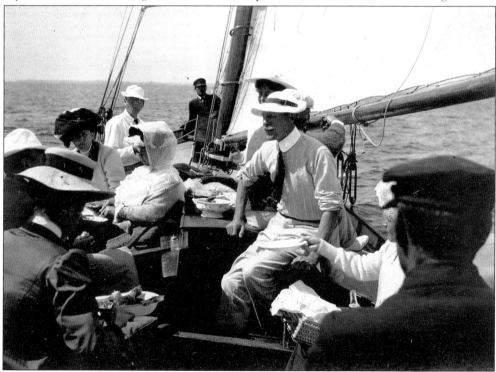

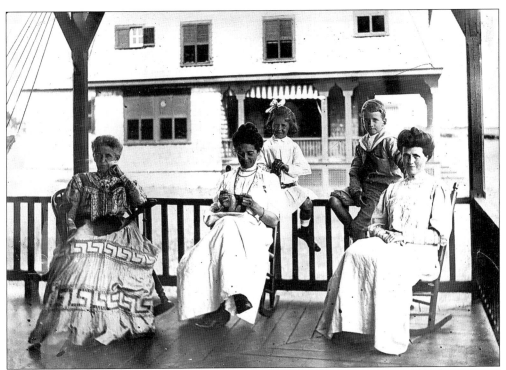

In the late 1800s, life for the summer residents was beautiful. Days were full of sports and reading, sailing and tennis, and socializing with good friends and their families.

Most of the homes on Old Black Point were large and comfortable. When utility services became available, many of the houses were converted for year-round use. On either end of the house is a sleeping porch.

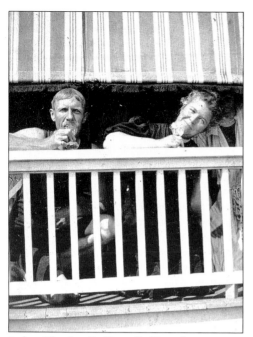

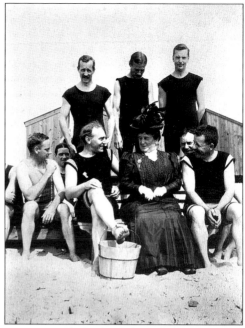

Judge Charles C. Nott (left) and a companion enjoy a cool drink while watching a tennis match. Also at Black Point, a group gathers for a swim (right). Note the bathhouses in the background. Out on the rocks (below), the woman appears to have "a touch of the vapors."

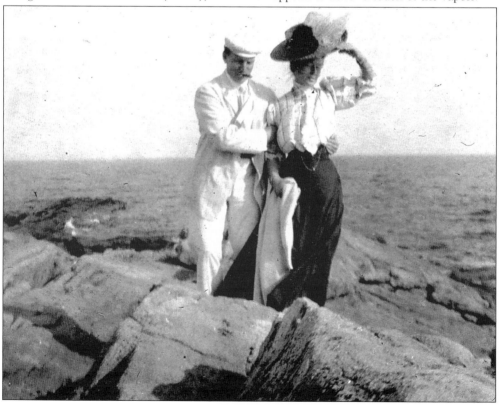

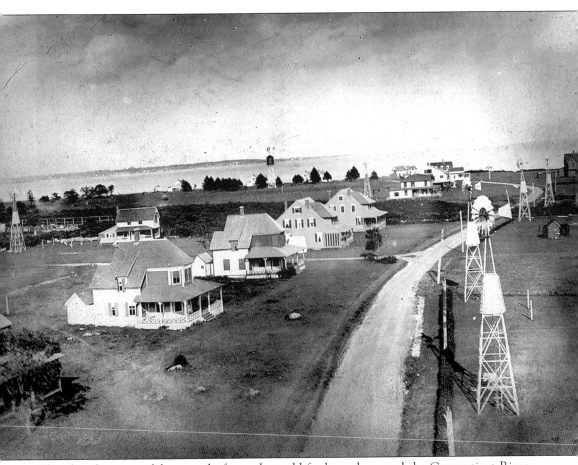

Close by, there were lakes, ponds, farms that sold fresh produce, and the Connecticut River. Yet most people stayed where they were, with everything they needed or wanted at hand . . . until it was time for the annual Harvard-Yale rowing regatta weekend on the Thames Rivers at New London. That was an event.

The Manwaring homestead was built on Old Black Point. In the early 1700s, the Manwaring family came to the area from England, where they had been landholders for centuries. They brought with them farming, shipbuilding, and master carpentry skills. They lived in New London, where Manwaring Street can be found, at a time of whaling fleets and shipbuilding in that growing city. In 1714, Thomas Manwaring and his bride moved to Black Point. Many later generations of the same family have lived here.

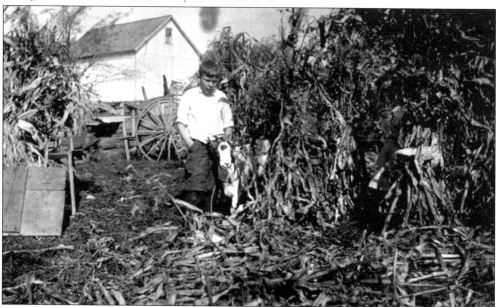

William E. Manwaring holds on to his pet goat at 8 Blackpoint Road, the first house on the left off Route 156.

The Manwarings enjoy a summer day at the beach. E. Hull and Florence Manwaring pose with their sons, from left to right, Arnold, Hull and William O. Manwaring.

Born to sail, Hull and William O. Manwaring enjoy a day on the lake. To this day, these brothers have never been far from the water.

Julia Manwaring Turner holds her eldest daughter, Cecelia. The mother of five children, she was married to Clint Turner and lived across from the Manwaring homestead. Her son Gordon still lives in the Niantic area.

Edgar Hull Manwaring was born August 18, 1904, the youngest son of Josiah and Grace Woods Manwaring.

Outside the house on a warm day, from left to right, are Grace Vernice Woods Manwaring, Edith L. Manwaring, seven-year-old neighbor Dwight Wilbur Beckwith (the father of Wilbur Beckwith, town historian) and William Edgar Manwaring, also aged seven.

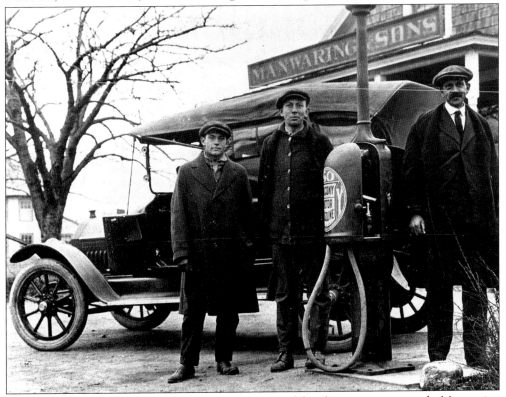

E. Hull Manwaring (right) and two other men stand by the gas pump outside Manwaring & Sons, the family-owned business on Black Point.

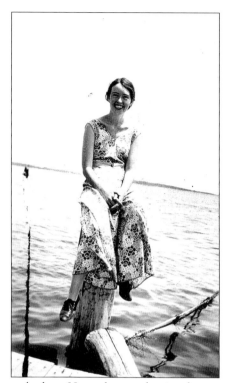

The Campions are another family that dates from the early days. Here, they are having fun on Black Point in the 1930s. Ed Campion (left) is shown with his catch of the day at his parents' cottage; in the background is Sunrise Road, and the houses are today located on White Cap Road. Mary Campion (right) sits out over the dock.

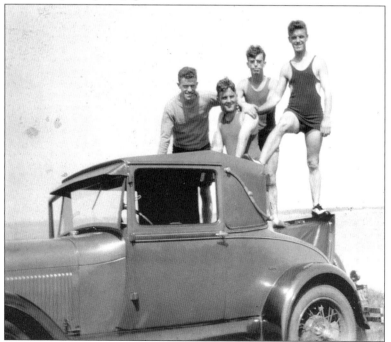

The Campion boys have claimed this roadster for Old Black Point. From left to right are Ed Campion, an unidentified friend, and Jack and Bill Campion. Where is the flag?

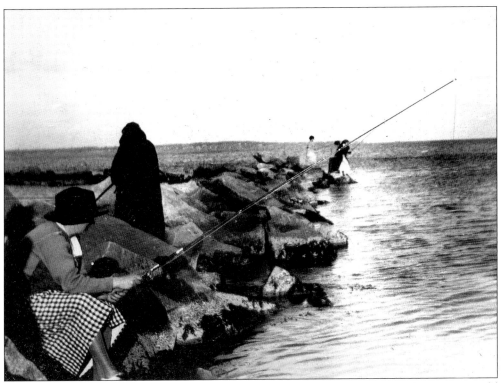

Growing up knowing about fishing was simply a matter of life. Everyone fished, even on a cold day, as shown here off Rocky Neck. In midwinter there was ice fishing on the lakes. Today, there are still boats in Niantic that take people deep-sea fishing for the whole day, in season.

Shown are five fishermen with a berry-picking basket. From left to right are Buster Mackey, Chet Baker, Thomas M.B. Watrous, Elijah Watrous, and Elias Coombs.

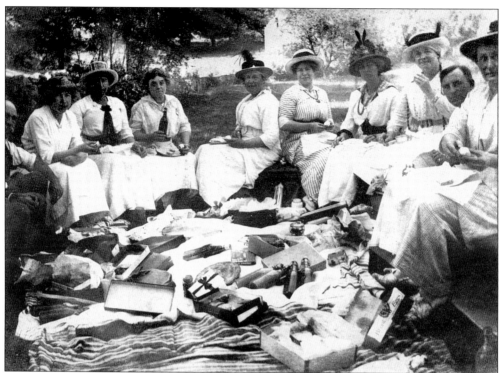

Although many picnics were organized as church socials and large-scale events, most were less formal gatherings shared by several generations enjoying the day together.

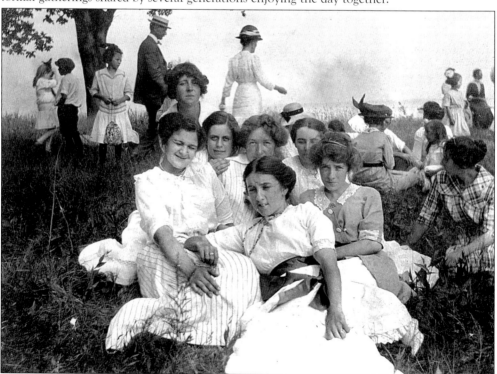

The white linens of the time could be relied upon to be strong and stay together through dozens of picnics and washings. Consider the time and energy required to keep them so white.

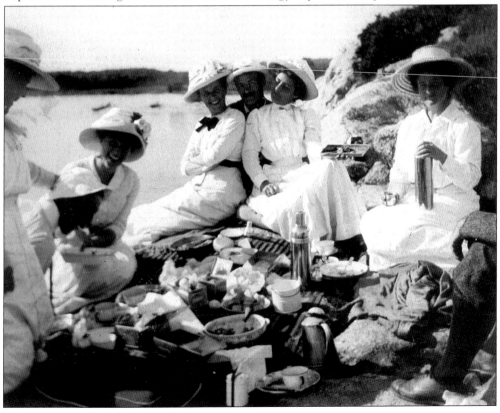

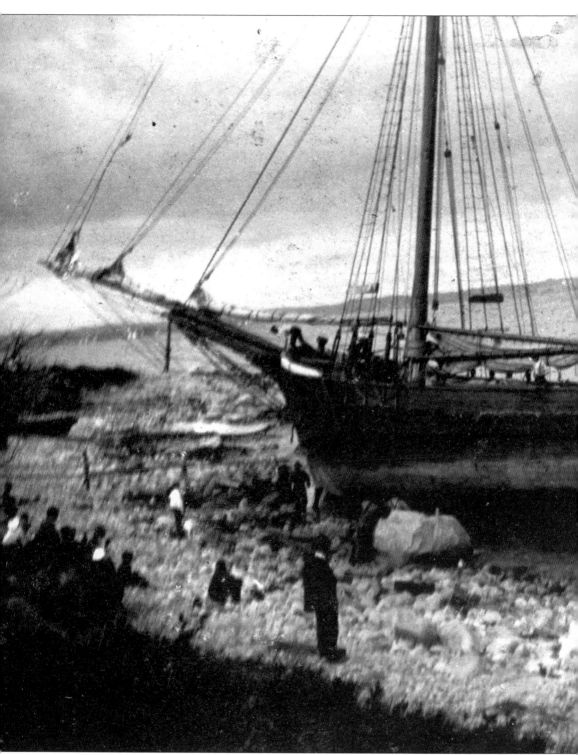

A beached schooner is evidence of the dangers lurking for even experienced sea-goers. This one on the coast at Black Point might have been an omen of the end of the era of wooden boats.

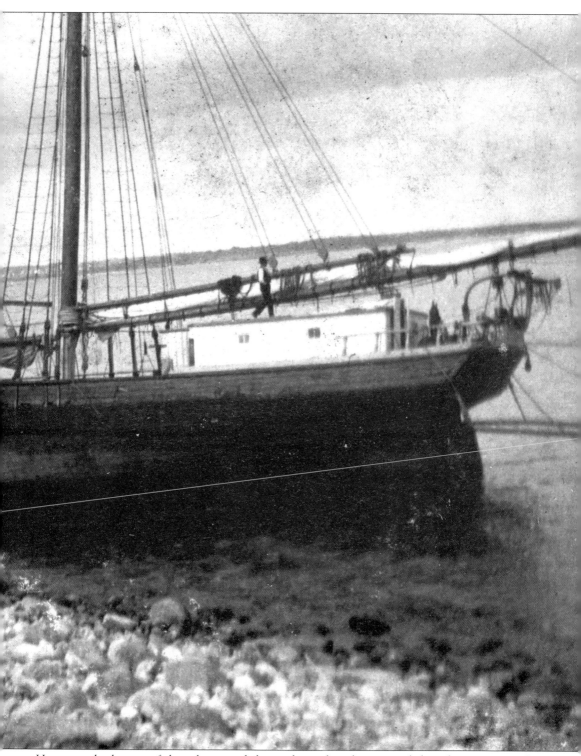

However, the beauty of these boats and the workmanship that created them has regenerated interest again and again, through many generations of people who love to sail.

Scouting has always been important to girls and boys in the area. Growing Up Green is more than the name of the local land conservation program; it is a way of life. Families are the most important successful business this town has ever produced, and it continues to be so today.

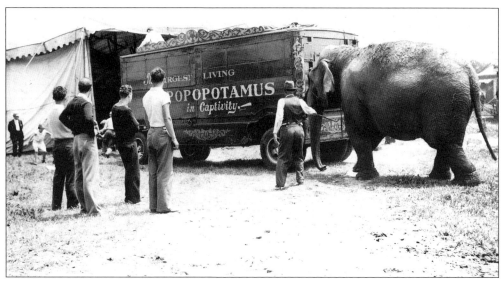

The June 24, 1908 issue of the *New London Day* featured a photograph of the Leon Washburn Circus parading on State Street on the eve of the annual Yale-Harvard rowing regatta. The paper reported, "The day before, as the circus paraded in Niantic, a fruit peddler's horse was scared by the elephants, collapsed and died." The circus came through town nearly every year, and Niantic always had a parade for it.

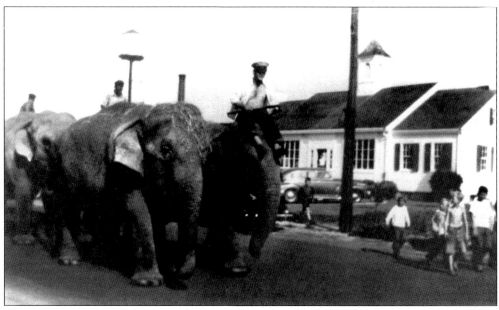

The year is 1948, and the circus has arrived. Dropped off at Niantic station, the elephants parade past Niantic Lumber, on Hope Street.

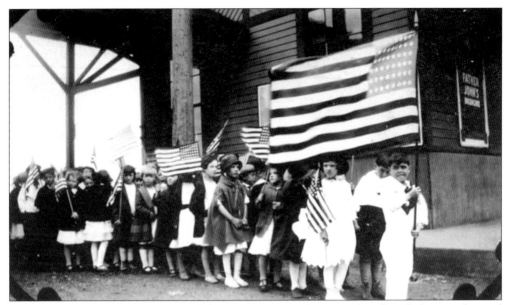

Children were brought into the celebrations at an early age. They loved the parades and dressing up, just as the adults did. After the parade, there was always a town dinner, with lots of cake and all-day games. Notice the flag with 48 stars.

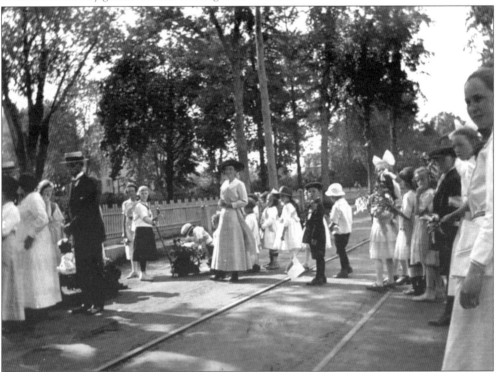

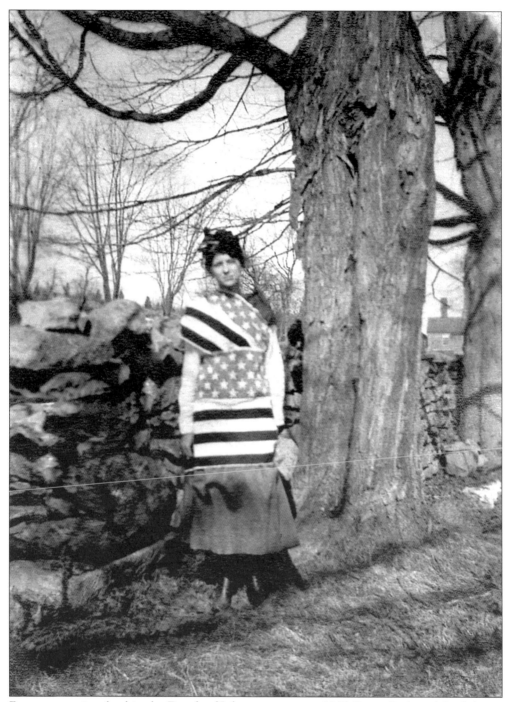

Everyone got involved in the Fourth of July ceremonies in 1917. Laura Peck, as Miss Liberty, carried the colors well. This kind of celebration, with parades and music on the green, went on all over the country and contributed to the feelings of pride and connectedness to fellow Americans, especially in this time of war.

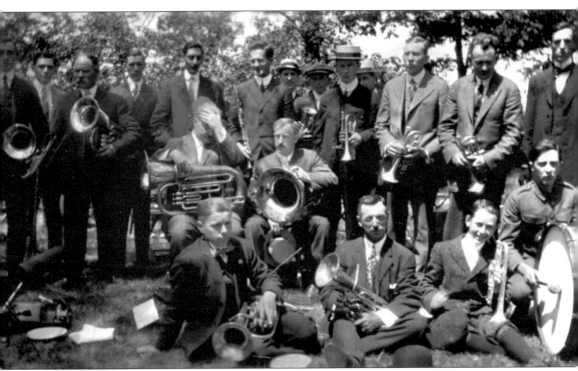

The band played for all occasions but seemed especially enthusiastic at patriotic holidays, parades, and special events. Needless to say, just about everyone in town attended such events. If they did not come, they were asked, "Why not?" Notice the young musician next to the drum.

EAST LYME STAR.

Eugene Davis,—Editor. **Niantic, June 1st. 1867**

WATERFORD.

Messrs. John Palmer and Frank Gilberts have opened a quarry on Millstone Point, (west side.)

Mr. John L. Watrous is about to erect a barn on his land west of his house.

NIANTIC.

HOWARD HOUSE.—This house has recently been opened under the superintendence of Charles Babcock, Esq. formerly of the Lyme Hotel. The house is being repainted, and as there is no pleasanter summer resort on the Sound, we expect Mr. Babcock will have a house full this summer.

GREAT SALE OF LAND.—All the land belonging to the Niantic tribe of Indians, is to be sold at Auction, Tuesday, June 4th, at 1 o'clock P. M.

It is difficult now to tell the "Indians of Niantic" from American citizens of African descent. [N. L. Cor. of Norwich Advertiser.]

It is also very difficult to tell two-legged Fox-es from four-legged ones.

BIG FISH STORIES.—The Norwich Advertiser has a great deal to say about trout, giving an account of two men of Middletown who caught 96 trout last Saturday; another party who caught 69 the same day; another man who caught 75 in one day; and the "local" closes by stating that "he is going some day, and is going to have doesn't say he is going to have trout for supper, for he may not get them. All this talk about a few small fish is very fine, but why don't you come down to Niantic where we have decent fish. Why, last Monday and Tuesday one man caught 24 striped bass off Rope Ferry bridge, and they were large ones too. What's the use of going off in the woods to catch a few small fish, when you can catch nice bass within four rods of a tavern door?

GENERAL NEWS.

Hay is now selling in Boston at $48 per ton, being about the highest price ever known in that city.

A million of dollars are annually made by the sale of Florida cedar wood for lead pencils.

Among the curious things at the Exposition is a bar of iron about as long and as thick as the pole of a carriage, tied in a knot as though it were a ribbon, without the vestige of a crack or flaw, and the visitor is assured that it was tied when cold.

Once a youth was leaving his aunt's house after a visit, when finding it was beginning to rain, he caught up an umbrella that was snugly placed in a corner, and was proceeding to open it, when the old lady, who for the first time observed his movements, sprang towards him, exclaiming, "No, no, that you never shall! I've had that umbrella twenty-three years, and it has never been wet yet; and I'm shure it shan't be wetted now.

A clergyman in Flint, Mich., on a recent Sunday, during the delivery of his sermon, denounced "waterfalls as abominable deformities, the fruit of depraved taste and woman's extreme vanity." On Monday upon in——waterfall was hung "this is the latest style." He says it——ed so like a large wasp's nest that he put it in the fire. A pretty widow of his congregation is accused of the trick.

Cherries have made their appearance in the Norfolk market—ripe and luscious.

The local newspapers of the 1800s gave opinions and information as frankly and adamantly as contemporary newspapers do, but they did so with a decidedly homey feel.

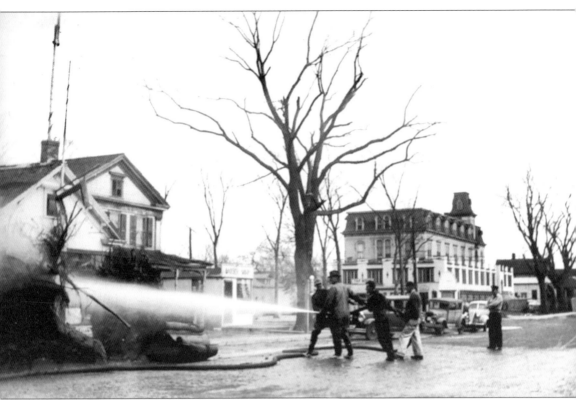

Fire Chief Legrand J. Hall directs his men in the cleanup following the hurricane of 1938, in the days before big power tools were available to help. Every piece of wood, every tree, every collapsed house had to be carted away by hand. Many homes in Pine Grove and on Saunders Point were destroyed. Farther up the coast, New London had extensive damage that took many years to repair; much was a total loss.

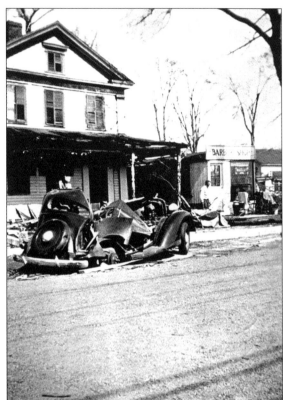

The 1938 hurricane destroyed many houses, business, and most of the elm trees that grew as a canopy over Main Street and Pennsylvania Avenue. Structures were rebuilt, new trees took the place of the old ones, but something significant was lost here.

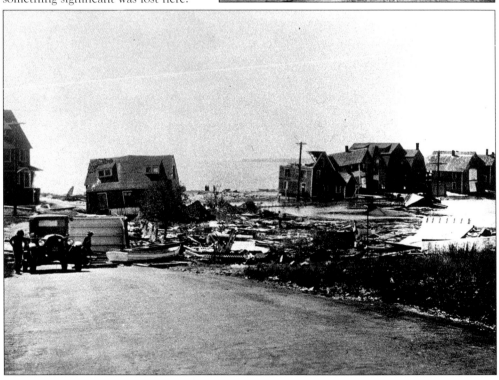

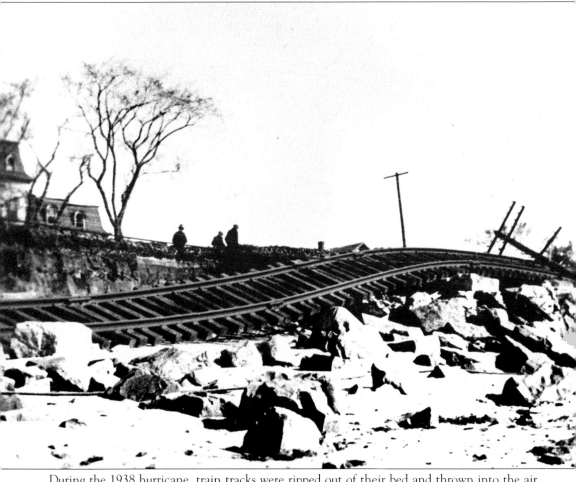

During the 1938 hurricane, train tracks were ripped out of their bed and thrown into the air, falling back to earth in peculiar patterns. The retaining wall alongside the tracks collapsed; much of the wall was washed away into Long Island Sound.

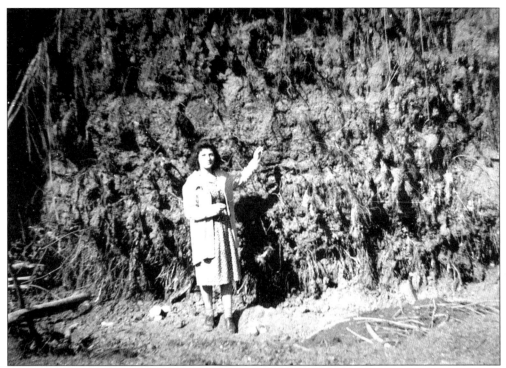

This is Bill Smith's yard, on Pennsylvania Avenue, showing the root of a tree pulled up by the hurricane of 1938. Imagine the force of wind necessary to pull this tree out of its bed and move it. For a long while after the hurricane, people thought twice about moving to the coast.

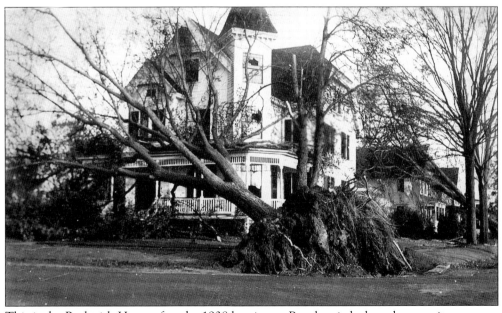

This is the Beckwith House after the 1938 hurricane. People cried when they saw it.

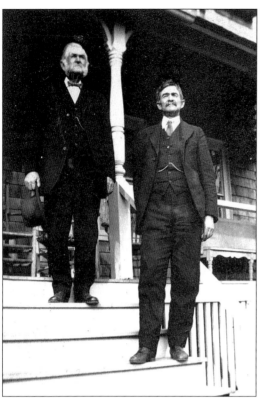

Frederick A. Beckwith (right), son of John Tyler Beckwith (left), was born in 1865. He served as first selectman for 45 years. He died in 1953.

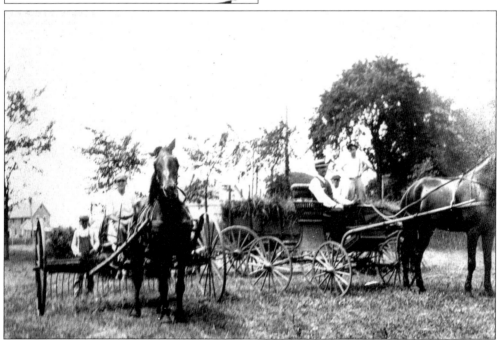

Frederick A. Beckwith taught at the high school and kept a livery business from 1890 until the automobile took the horse's place. He had an extensive coal and wood business in town and was very active in his church.

Frederick A. Beckwith married Marian Stannard Mott. Elected first selectman, he served almost 45 continuous years. He served in the state legislature in 1907, 1927, 1929, 1931–1947, and 1949, when he was the oldest member of the Connecticut General Assembly. He also served as senator from the 20th Shoe-string District in 1925. The Beckwiths had two children: daughter Lesley Mott Beckwith and son Tracy Beckwith. Lesley Beckwith worked at the town hall for many years. She had been clerk at Niantic Baptist Church for 50 years when she died at the age of 91 in 1985. Neither she nor her brother married.

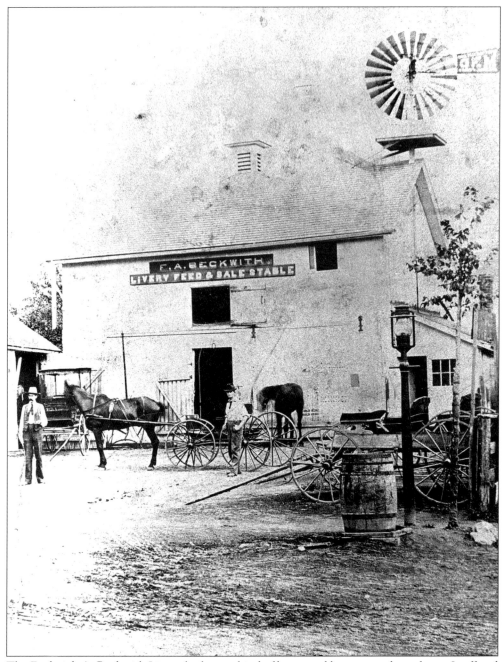

The Frederick A. Beckwith Livery had every kind of horse and buggy, coach, and cart. It offered everything from elegant formal vehicles to farm tractors. The business continued in operation until the very last moment, when automobiles brought it to a stop.

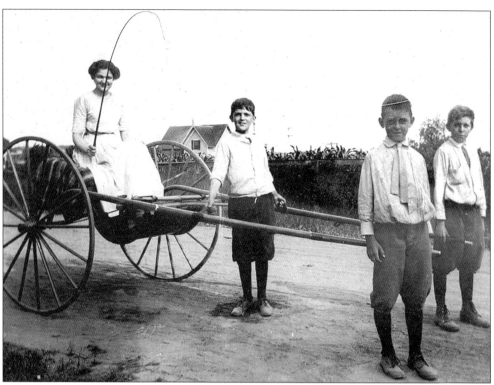

With whip in hand, Lesley Beckwith (above) goes out for a ride. The Beckwith coach (below) was made to be photographed.

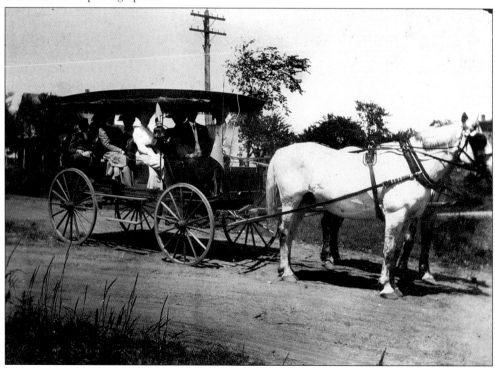

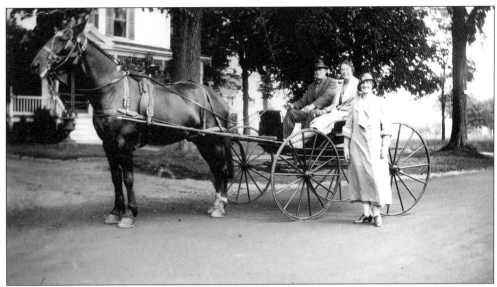

Shown is another beautiful horse and carriage from the Beckwith livery. The Beckwiths (below) head off for a spin—with a two-horsepower "engine."

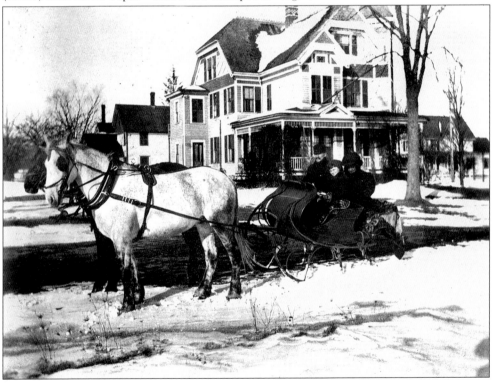

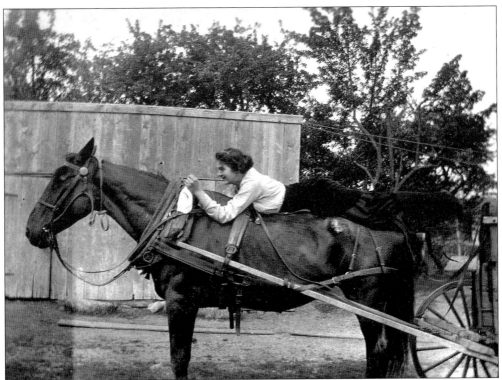

Lesley Beckwith was an interesting person. Tall and quiet but with an obvious sense of humor about herself and the world, she is shown in many pictures making fun of herself and laughing with the camera. She ran a jitney service out of the Beckwith stables, picking people up at the train station and shopping for people as she made her rounds. She worked for the town and for her church. The boys (below) look ready but not able to go for a ride, too.

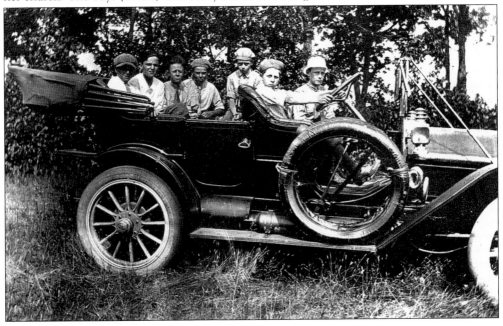

The Chapman family house was on the Shore Road in South Lyme. Robert Chapman was a farmer and quarryman. He was the great-grandfather of Olive Chendali and Norman Peck. His granddaughter Andrea Chapman owned the property where Chapman Farms stands now, on Pennsylvania Avenue in Niantic.

Laura Littlefield Peck (seated), wife of Frank Peck, holds one of her daughters, probably Helen. The Pecks had five children and lived over the town line in South Lyme. Their grandson Norman Peck, a longtime president of the East Lyme Historical Society, continues to educate the next generation about the history of the area.

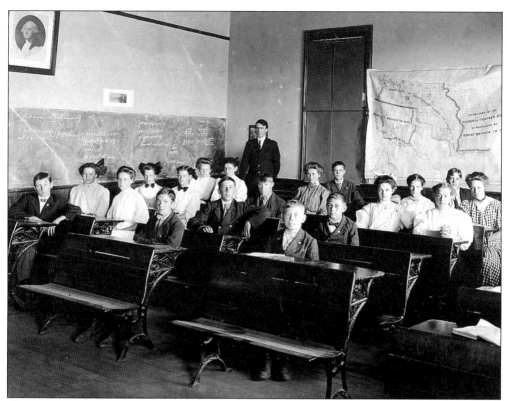

Shown is a class at the old schoolhouse in Flanders in 1909. Schools such as this had neither central heat nor air-conditioning—just bare-bones rooms. Yet teachers taught and students learned. Even in the mid-1800s, Connecticut had a school budget of more than a million dollars.

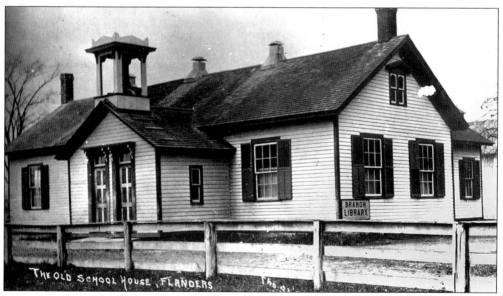

Two

FLANDERS

Going west out of Niantic meant going on Pennsylvania Avenue toward the Flanders area. This area was developed before the bank (waterfront) of Niantic was. In fact, many fishermen and sailors and their families lived here, about five miles inland. Originally, mostly farms populated the landscape after passing out of Niantic, but Boston Post Road in Flanders brought the Golden Spur amusement area, Beckwith's shipbuilding yard, hotels, restaurants, and other businesses. The trolley got passengers there in style.

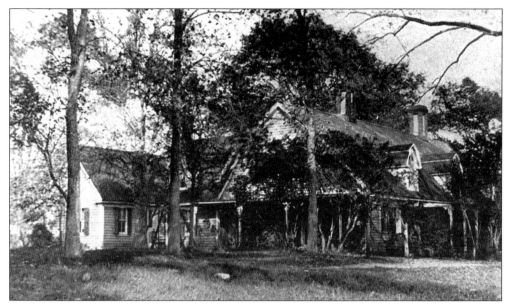

George Washington and the Marquis de Lafayette are said to have stopped in East Lyme at Caulkins Tavern, on Boston Post Road, after visiting with John McCurdy in Lyme. McCurdy actively protested against the Stamp Act; there were people on both sides of the issue at that time, including some prominent local families who supported England. Caulkins Tavern sat on what is now Four Corners. It must have been a welcome sight to coach passengers on their way through to New London or Hartford.

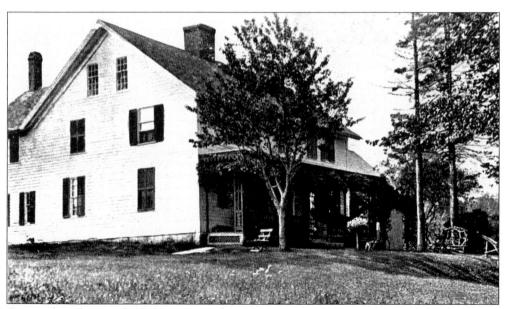

Comstock Lodge was deeded in 1774. In the 1920s, it was the property of Mrs. H.E. Hudson, daughter of John J. Comstock, the last of the line of a fine old family who had been active in the community since Colonial days.

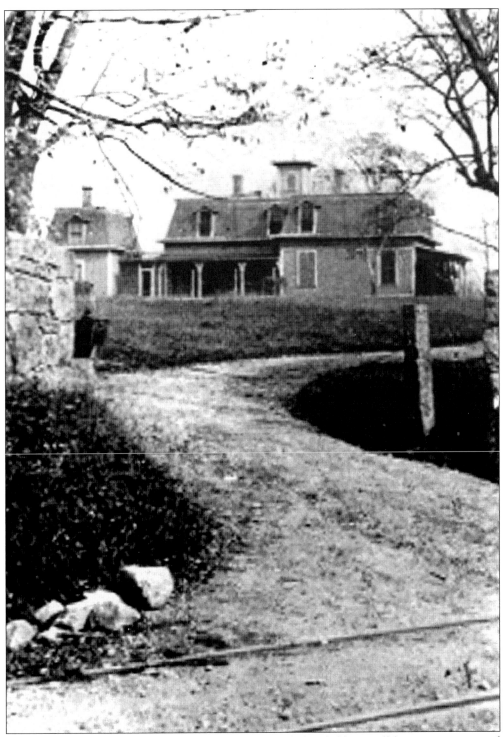

Cutter's mansion was owned by a New York City family headed by a well-known inventor and state senator. Lottie Reynolds operated a private school on the property for a while. Note the trolley tracks on Boston Post Road near Flanders Four Corners.

The Scotts were among the most visible of the Flanders farming families. Michael Scott, his wife, Clara, and their growing family (left) arrived in 1892 to join friends from home (England) who had come to work at a woolen mill. All of the family members worked. When the small mill closed, the Scotts cut wood, for which they were paid 50¢ a cord. Times were very hard, but the family managed to buy 10 acres and start a farm. Wilfred Scott (right), born in 1887, was a respected member of the East Lyme community and a member of the Connecticut state legislature.

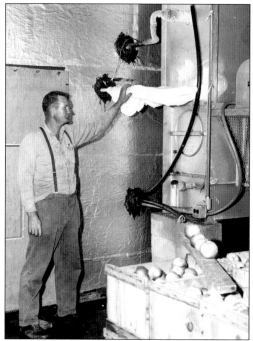

With Yale University, Wainwright Scott developed a system and unit for keeping apples fresh over the winter. Known as an apple crisper, the unit was a major development in the field. Scott's collaboration with Yale continued for many years.

The Scott sisters for many years lived in the old Scott Road schoolhouse in Flanders.

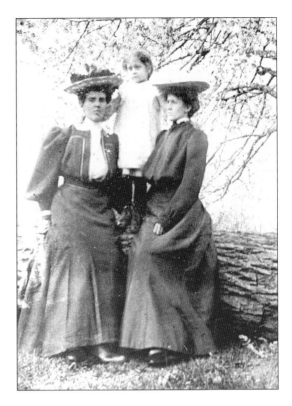

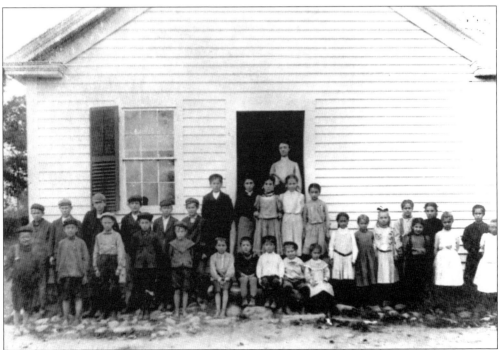

This is the Scott Road Schoolhouse in Flanders. When this picture was taken, classes were still being held at the school.

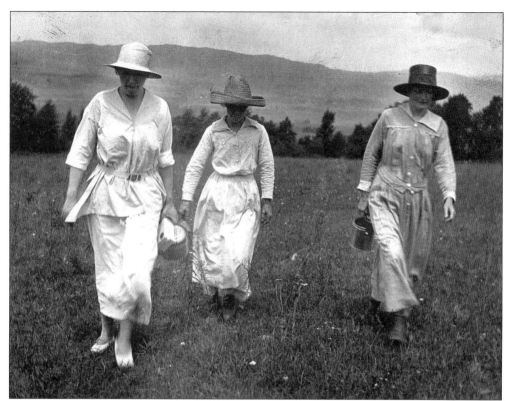

Berry picking was popular long before the Scott family orchard had "pick your own" seasons for berries, fruit, and the children's favorite, pumpkins. Driving out of town was always an adventure, an opportunity to spend a pleasant day with friends, talking and laughing while searching for the wild fruit. For others, reading a good book was the perfect way to relax.

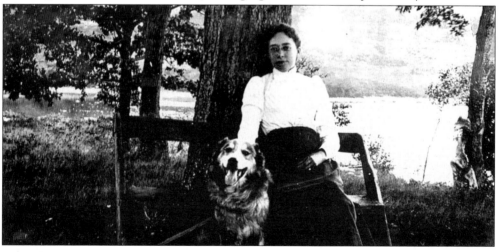

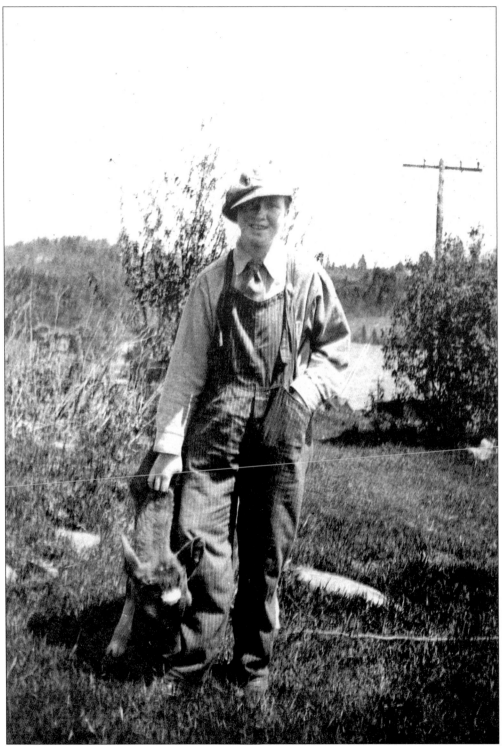

People used to keep deer as pets, as this boy did. Farm youngsters grew up knowing about animals, both wild and tame.

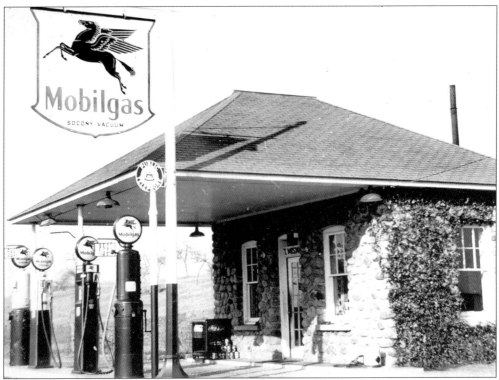

Three branches of the Boston Post Road came out of New Haven, one of which ran from Old Lyme through Flanders. The small gas station pictured here was owned by Thomas and Rosalie Misniak, a local couple. It is currently being restored by a new generation of relatives, the Sheridan family.

This is Alice's Store, on Boston Post Road in Flanders.

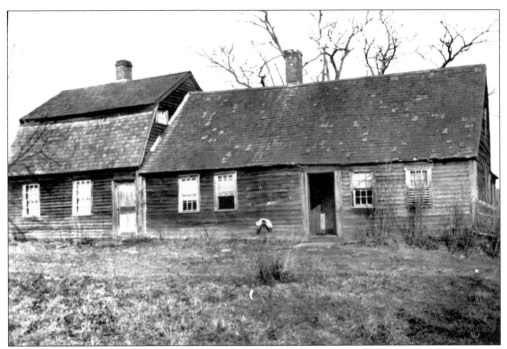

Pictured here are the Smiley house (above) and Max's (below). Max's is still the location of a family-owned store. There are many old houses in the Flanders area, both on the main roads and on the winding back roads. Today, it is possible to recapture the past just by parking the car on one of these roads. The amount of open space is amazing in this day.

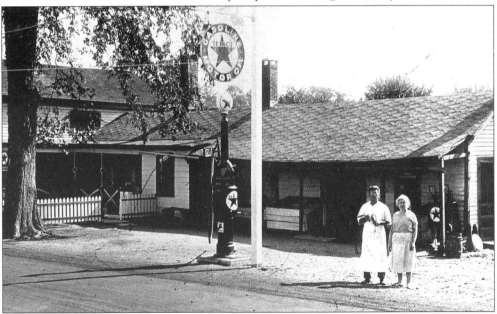

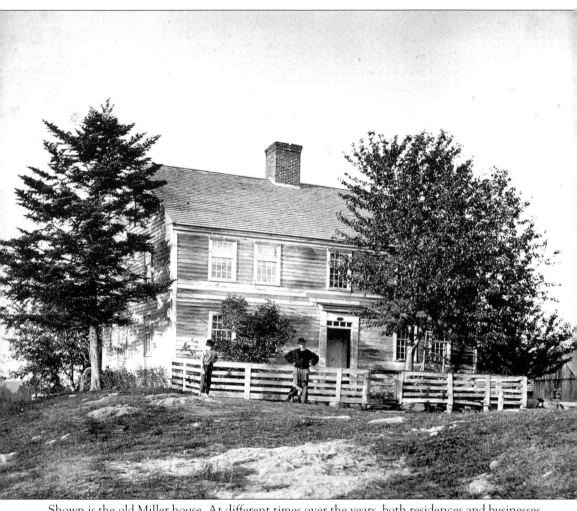

Shown is the old Miller house. At different times over the years, both residences and businesses have been built on Boston Post Road in Flanders.

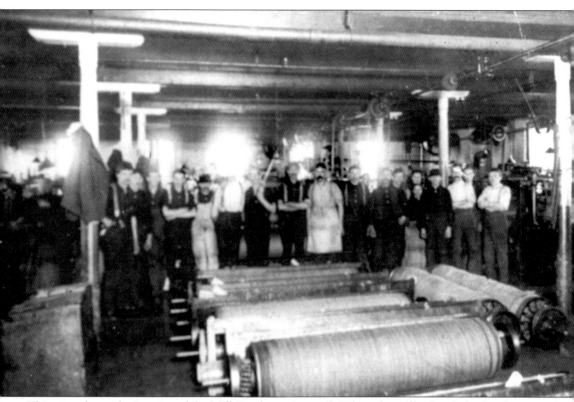

This view shows the interior of the Mill Road weaving mill. When the mills closed, the families who had been employed by them bought, little by little, small acreages to farm.

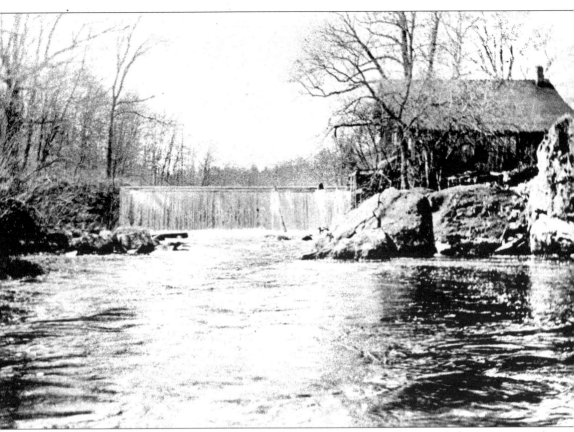

The first mill in Flanders operated for more than 50 years, manufacturing ladies' suitings and novelties. Several later mills made cotton roping; also, there were gristmills and sawmills. The mills all ran on the waterpower of Latimer's Brook, except for one mill that was located at Pattagansett Lake on Mill Road and Boston Post Road. That mill site included long houses, built like the Native American structures of the same name, in which several families lived together. The weavers and farmers of Flanders, many of them relatively new to this country, were self-reliant, skillful, and hardworking.

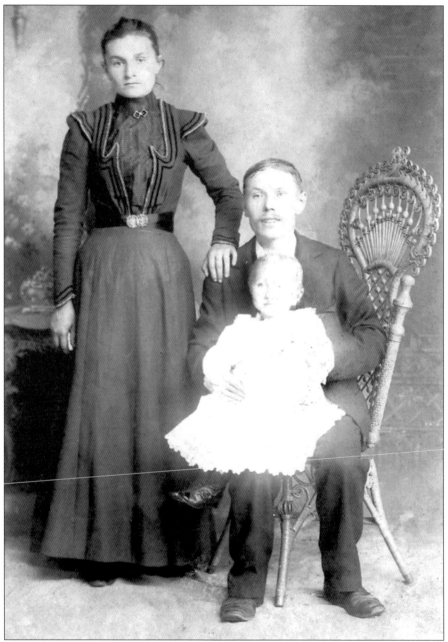

Two brothers of the Havrilla family came to East Lyme in the 1880s. One bought a farm on Roxbury Road. The other purchased 28 acres in the Boston Post Road area near the Scott orchards. At that time the island did not exist. It was a meadow until a dam was installed much later. Pictured with her parents, Mary and Michael Havrilla, is Helen Havrilla. Born here, she married Michael Tverdak from Bayonne, New Jersey, and had four children. When Rocky Neck Park opened, the spillover of visitors who were turned away when the park was full looked for other places to stay in the area. Gradually, Island Family Campgrounds was developed. Ed Tverdak has been in charge of it since his parents died. Many of the same people from New Jersey, New York, and Massachusetts have been returning for more than 30 years.

The beach at the island looks up the lake and across it, offering a lovely view and spectacular sunsets over the hills beyond. Generations of families have thought of this place as their own; many from New Jersey and New York have come back year after year for more than 40 years.

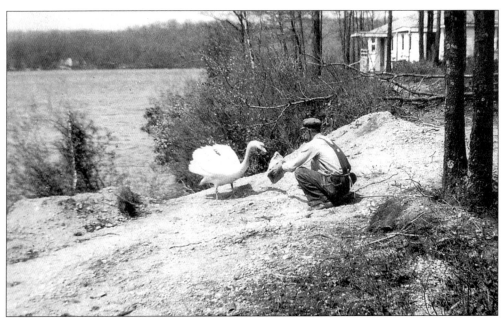

Neighbor John Misniak is feeding the two swans on the island. There has been a pair here for as long as anyone remembers, and they are enjoyed by everyone. Geese, heron, and many varieties of ducks and song birds call the island home. Ed Tverdak and his sister Eleanor Yuhas say the only wildlife on the island that they like has wings.

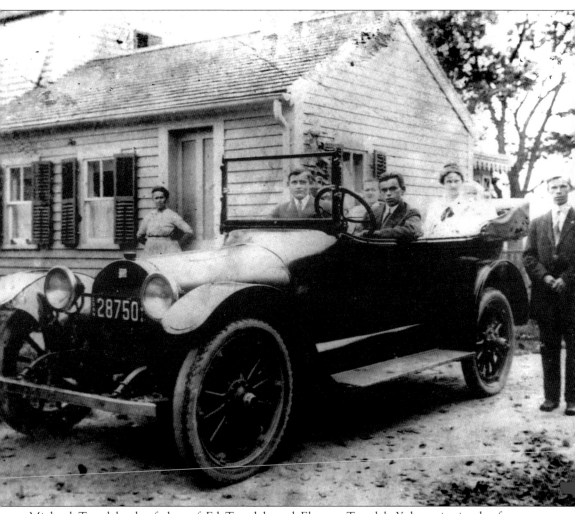

Michael Tverdak, the father of Ed Tverdak and Eleanor Tverdak Yuhas, sits in the front passenger seat. He was a man who loved the quiet outdoors and had it all on Lake Pattagansett for many years. As a young man, he would motorcycle to East Lyme from Bayonne, New Jersey, to visit his future wife, Helen Havrilla. It was love at first sight.

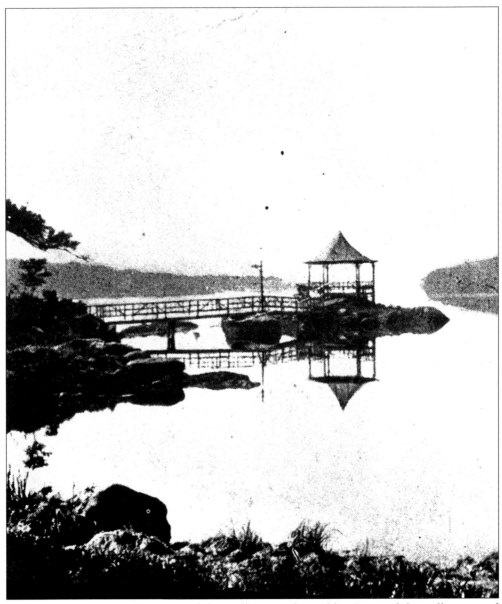

If you build it, build a trolley, too, and they will come. The Golden Spur and the trolleys arrived in Flanders at about the same time. For years, both were a hit with the local people and those from surrounding communities. Not a coincidence, the same people who invested in the Golden Spur invested in the trolleys.

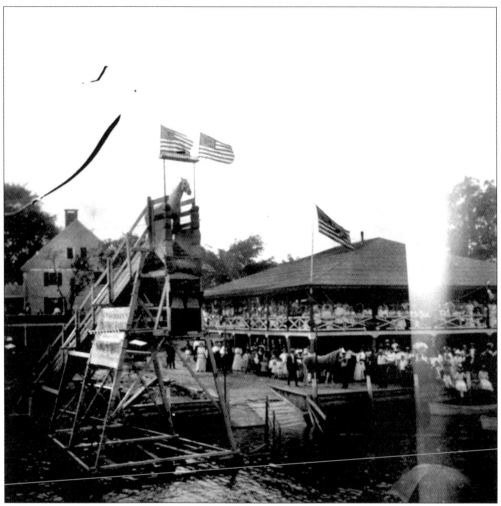

In today's world, this attraction would still draw a crowd. These horses are the one thing everybody mentions, even those who never got to see them in action. Notice the spectators holding their breath.

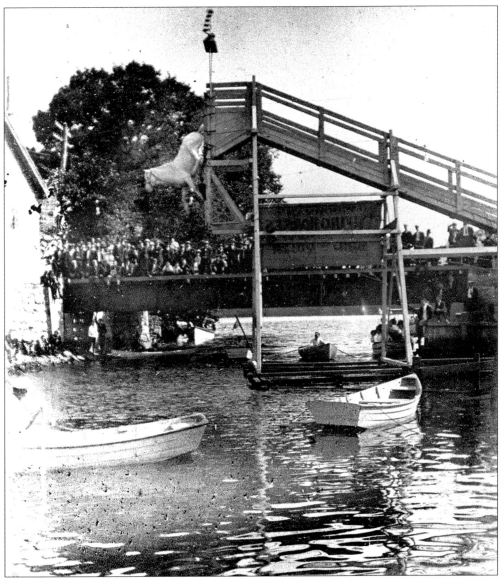

In the early 1900s, the Golden Spur became a popular destination for families. It was full of sights, rides, and recreation. The stars of the show were King and Queen, the diving horses. They went up a ramp and, at a given signal, leaped into the pool below, to loud applause and delight. The horses always drew a big crowd, and people tended to come back with friends to show them the memorable performance.

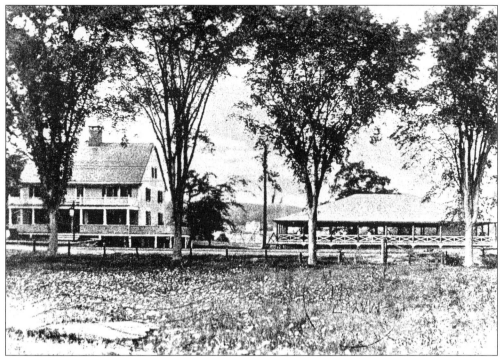

The Inn at Golden Spur was situated at the head of the Niantic River. It featured a restaurant, gardens (including one called Little Japan), a pavilion, and a roller-skating rink. One could visit in the daytime or the evening or stay overnight. People came in the evening to enjoy a beautiful dinner overlooking the river (below), to watch "the Greatest Living Roller Skater of Modern Times," or to dance the night away.

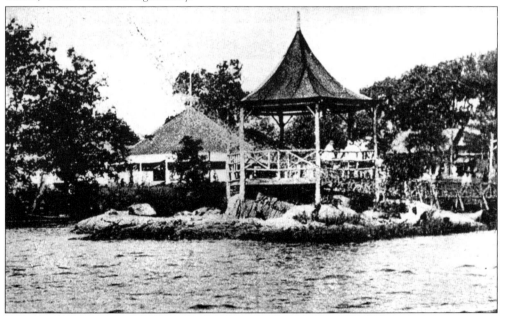

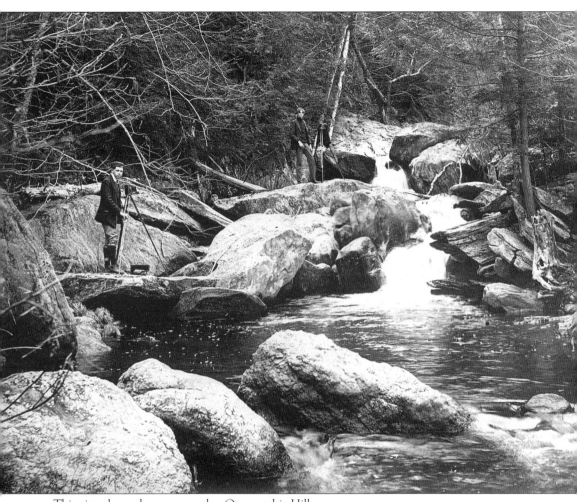

This view shows the quarry pool at Oswegatchie Hills.

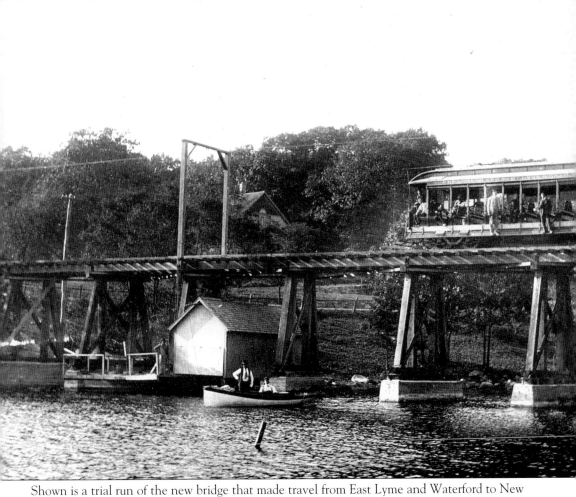

Shown is a trial run of the new bridge that made travel from East Lyme and Waterford to New London much easter. In the boat are John Manwaring (left) and Lawrence Smith.

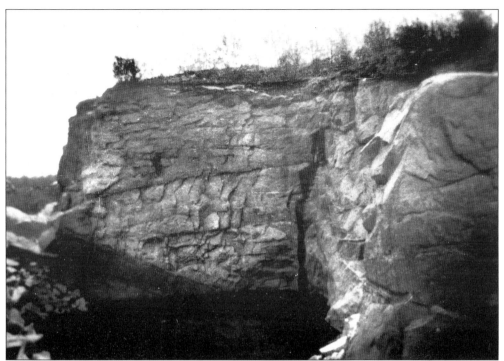

The industry that brought national attention to the area was started by Angelo Malnati, a visitor to town. Malnati was a quarryman. When he noticed pink stones on a path, he knew what he was looking at: golden pink granite. The rest is history. The stone was shipped all over the country. The pink, as the stone is called, is encased in shale and has to be uncovered— a difficult but profitable job. It is used primarily in monuments and as building veneer or facings. The memorial in Washington, D.C., to men lost in World War II is made from Niantic pink granite.

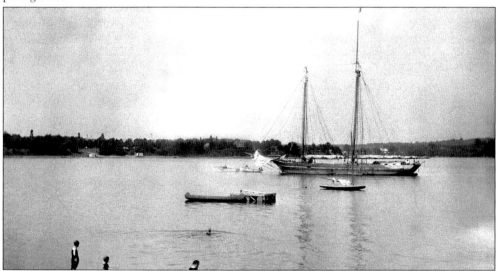

This two-masted schooner is at the quarry dock mooring near the head of the Niantic River. Stone was picked up and delivered to ports in Hartford, New York, Washington, D.C., or Baltimore. The dock can still be seen but is no longer used for that purpose.

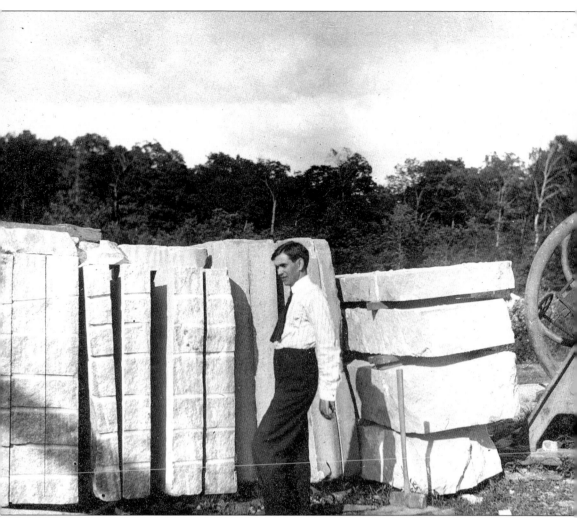

Claude Clarke is pictured at the quarry at Oswegatchie Hills. This was big business in several areas of East Lyme, from Black Point on the coast seven miles inland to Oswegatchie Hills. The quarry product was courtesy of the late Pleistocene glaciers, which deposited stone as they receded.

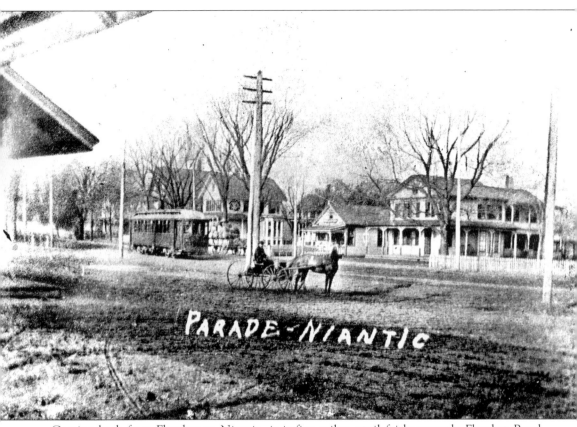

PARADE-NIANTIC

Coming back from Flanders to Niantic, it is five miles; until fairly recently Flanders Road, which becomes Pennsylvania Avenue midway, was undeveloped. It started to get busy in the 1930s. The *New London Day* reported "heavy traffic in both directions" at that time. When this picture was taken, the trees and the residential look presented a charming image.

Three
NIANTIC

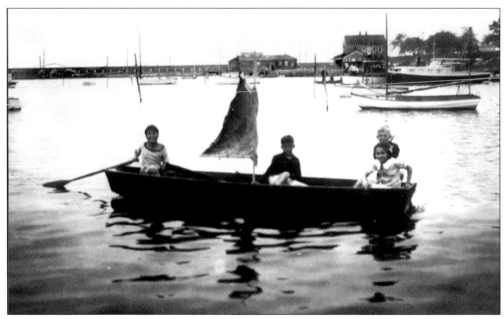

This picture sums up a lot about East Lyme, past and future. From left to right are George Papas, Norman Peck, Walter Rice, and an unidentified girl. The youngsters appear unafraid, ready for an adventure they themselves will create, in a town small enough to offer security because everyone knew their neighbors. "After school" meant getting outdoors, climbing in the old quarry, and going down to the bank (waterfront) at Niantic to see what boats had come in during the day. What a gift their parents gave these children, and it was only yesterday.

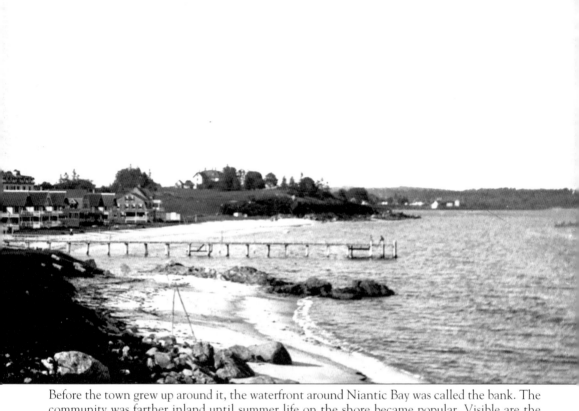

Before the town grew up around it, the waterfront around Niantic Bay was called the bank. The community was farther inland until summer life on the shore became popular. Visible are the sanatorium (left) and McCook's Park (right distance). Niantic had a fleet of some 50 boats in the 1880s, many built locally by men who also used their carpentry and joinery skills to build a number of Niantic homes. The well-to-do summer residents appreciated and relied on these talented craftsmen to create for them comfortable, solid structures suited to their tastes. Many of the homes remain today.

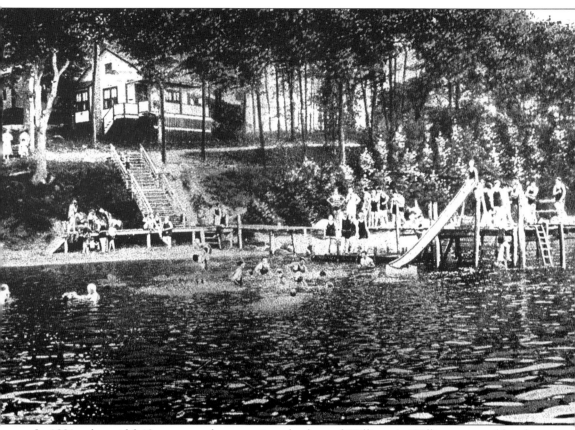

In 1881, a beautiful 40-acre parcel, at one time the farm of William A. Williams, was sold and transformed into a religious camp for families during the summer months. The Connecticut Spiritualist Camp Meeting Association was one of several in the state at the time. Pine Grove offered swimming, tennis, and dancing (chaperoned) in a pavilion. Great revivals were held there, and they were well attended. By the 1930s, it had become a summer resort. The tabernacle was turned into a dance hall, and cottages were open to rental by non-Spiritualists. The hurricane of 1938 caused severe damage to the camp.

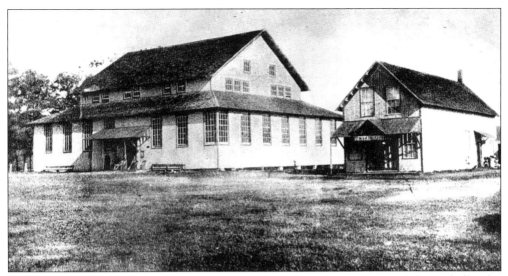

Both pictures were taken from Pine Grove, and both show the pavilion and dining hall. Also visible in the lower view are what was known as the Stone House (mid-center shoreline) and Saunders Point before development—a view obscured today by houses and trees. The late Pleistocene Age left its mark in many places along the local coast, including Oswegatchie Hills (far distance), which rise immediately from the shoreline of the Niantic River up almost 300 feet, giving a view of where the river empties into Long Island Sound. The local land conservation trust is currently working, with some success, to save from development as much of Oswegatchie Hills as possible.

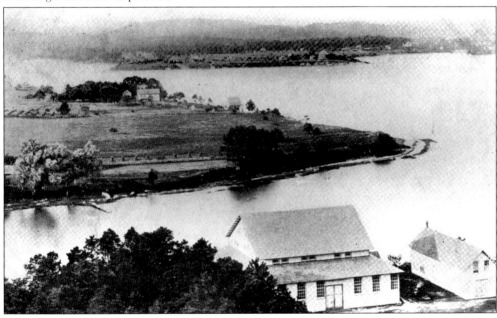

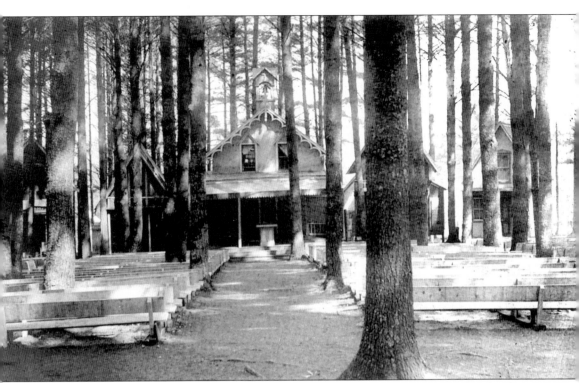

On the Niantic River, overlooking Smith Cove, the Spiritualist campsite was a lovely place with many lush pines. Members could rent tents or cottages for a few dollars a year, with leases for up to 99 years. By the end of the first year, 138 cottages had been built and leased for the summer.

The McCook family came to Niantic out of necessity and stayed out of love. In a three-year period, Rev. John James McCook bought Champlain's Point, which remained opened to the public for use, and built a very handsome house, in which he held Episcopal services in a private chapel. Later, he donated the land for St. John's Chapel.

The generosity of the McCooks and their love of this place is beyond doubt. The McCooks fought an effort by the state to try to condemn the property and take it over for other uses. The family had to put up with complaints from fishermen, who claimed they were being stopped from setting nets off the point where the McCooks boated. Ultimately, the McCooks sold the property to the town for a park at a price lower than they had been offered by developers. The house was destroyed after the town was unable to develop a plan for using it.

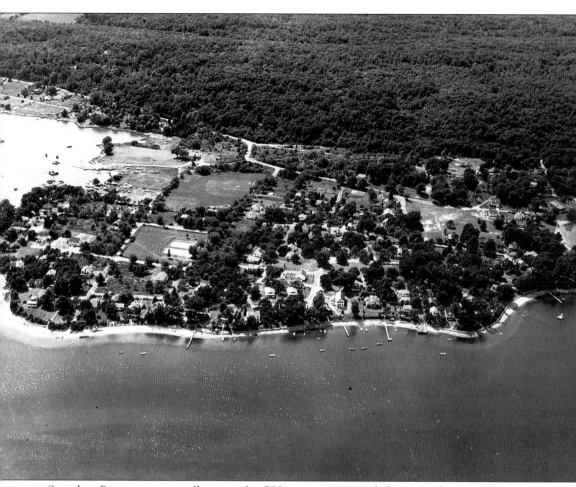

Saunders Point was originally part of a 500-acre grant awarded to Lt. Thomas Bull for his service during the Pequot Wars. When Bull died, he left 800 acres—part of the present community—which were sold to the Nehemiah Smith family. The Smith family owned it or a part of it for more than 250 years. In 1816, a house made of locally quarried granite was built on the waterfront. It became a landmark known as the Stone House.

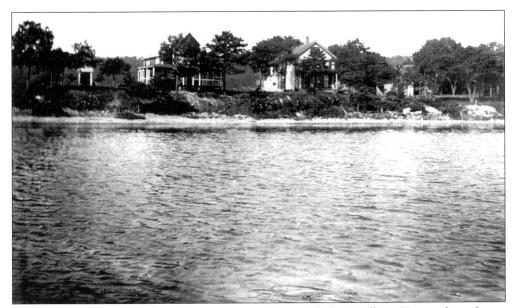

A sizeable tract at the center of the point was sold to Nicholas Caulkins 50 years later. It was subsequently deeded to Caulkins's daughter Mrs. Christopher Saunders, giving the location its name Saunders Grove—later, Saunders Point. The family home (above) is known as Glossenger Cottage. In 1931, there were 110 homes on the point, most of them summer residences that were simple but well built.

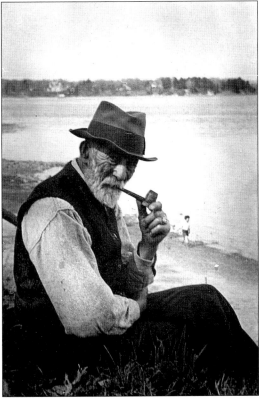

The man pictured here is Arthur "Cappy" Saunders, a beloved character who "never met a stranger," as the saying goes. His short white beard, dark pants, faded blue shirt, and dark vest, topped off with a fedora, showed his sweet sense of humor. His humor was contagious throughout the community, generating ideas such as the Saunders Point Snobs, a group that did not take itself too seriously, and the Great Egg-Catching Competition. Saunders is missed by all who knew him.

Some say Toad Rock, on Pennsylvania Avenue, is as ancient as Oswegatchie Hills. It is one of those funny landmarks that everyone knows but not everyone has seen, no matter how many times they pass it. Toads are in the eye of the beholder, it seems.

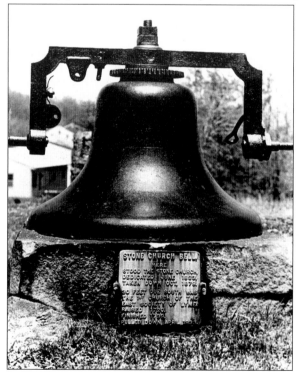

This is the memorial across from the Old Stone Church cemetery on Society Road.

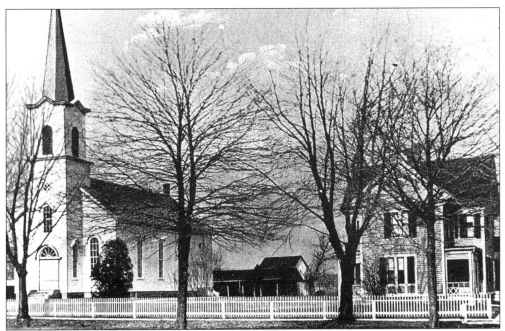

According to *Coke's Commentaries*, "It can not be a town in law, unless it hath, or in past time hath had, a church and Celebration of Divine services, sacraments and burials." Early English townships in New England were known as parishes. Church and state in Connecticut were held separate, but the churches were a major force in every community. They influenced social life and education. For example, the blue laws were based on biblical influence, and infractions were punished accordingly. The first church was in Lyme. Many people had no way to travel other than by foot. It was a grueling task to walk the nine miles to an unheated church to hear services and then retrace a path homeward bound. Socializing was frowned upon on the Sabbath in those early days. In 1718, the East Society was created, and a small church was built on Society Road in Niantic. With it came responsibility for education; the Colonies were under the laws of the British, so the development and administration of education fell to the church, to keep and staff the schools and mete out the laws as they knew them. The first schools were formed, funded by the parishioners. People who lived in Flanders still had a hard road to travel to get to church. Many walked up Ancient Highway from Boston Post Road on to footpaths, a distance of five or so miles to Society Road and back. In the 1830s, the Congregationalists built a stone church to replace the original small wooden structure. The Methodists had built their church in 1810 on East Pattagansett Road and later on Main Street. When the railroad came through town and the population expanded downtown, yet another new Congregational church was built in 1879 to accommodate the increased population. The two churches merged 140 years later and became the Niantic Community Church. When the Congregational Society built a new church (above) on Lincoln Street, it sold the Old Stone Church to be demolished. Thus, one of the town's oldest landmarks was lost, with only the bell (shown on page 86), now silent, marking its place just across the road from the cemetery on Society Road.

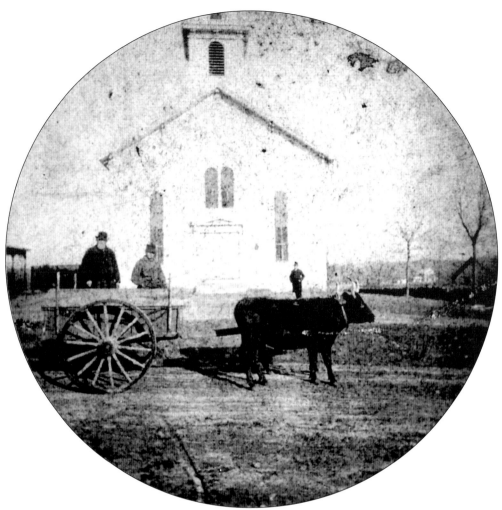

The Baptist Church in the Lymes was formed in 1752, after four years as the Separatist Church. The First Baptist Church of East Lyme began in 1839 and, in 1929, became the Flanders Baptist Church, which it remains today.

In the 1870s, the Methodist Episcopal Church (shown) was built on Main Street. The Roman Catholic church, St. Mathias, was originally on Boston Post Road in Flanders. Completed on August 1, 1943, it later moved to Chesterfield Road, where it now occupies a new, larger building.

This is Dwight Wilbur Beckwith, near 14 years of age, *c.* 1918. He was the father of Wilbur Beckwith, the current town historian. There are many families with the Beckwith name, not all related. Their roots go back to the Norman invasion of England and to the earliest days of this country.

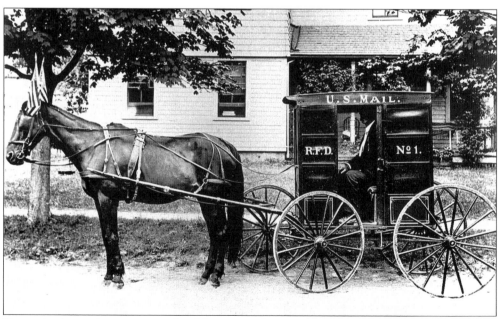

Shown in the mail carriage outside a Niantic residence is Percy Morgan, the rural free delivery postman. Sometimes he would pick up items on his weekly trip to New London for people who could not travel.

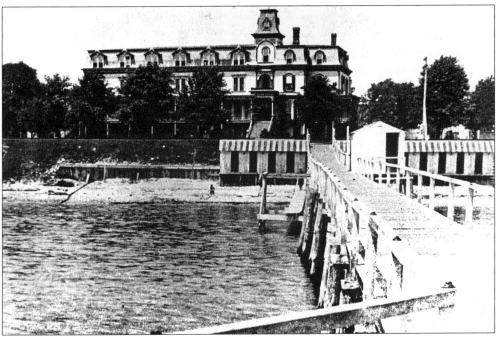

The Morton House was built in the 1850s by a man people called "the rich Mr. Beckwith." He was from Hartford. The Morton House quickly became a landmark. The size, beauty, and position of the place must have made train passengers ooh and aah as they passed by; many came back to stay in the summer. Today, this wonderful old building is being refreshed. It still has rooms upstairs and a restaurant.

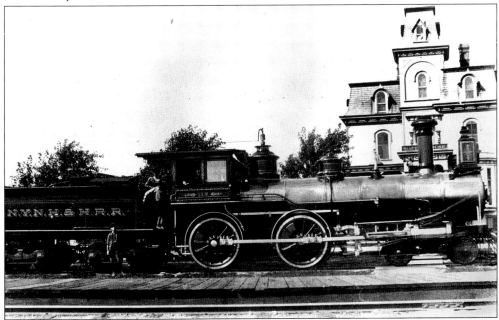

Often, summer visitors' first views of the Morton House were from the train on their way to someplace else. However, they generally came back because the hotel, built in 1868, was beautiful.

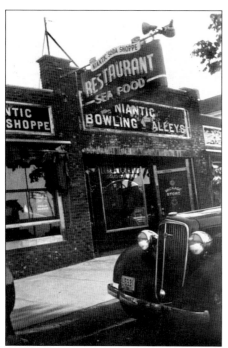

Main Street was being "citified" with two brick-faced buildings owned by S. Deligeorges and L. Dousis Stores. The buildings housed shops, the United Fruit Company, and a beauty parlor run by Mabel Redfield and Frances LaCavera. At the rear was a bowling alley, whose advertisement read, "Where Good Fellows Get Together." This enterprise created the first mall concept to be developed in Niantic. Later, homes were added by the developers.

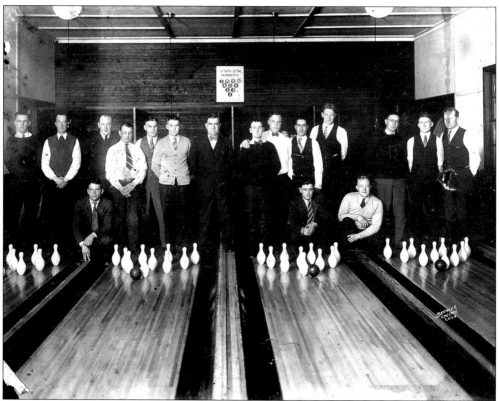

These are the "Good Fellows" of the advertisement mentioned above. By today's standards they are wearing rather formal attire for bowling.

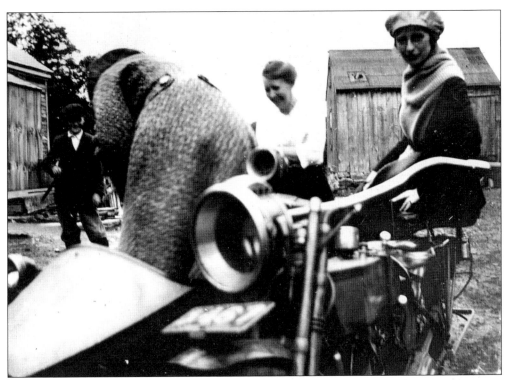

There is no need to say what these are. Aficionados of the classics know. These young women with motorcycles were ahead of their time.Harley Davidson replaced the horse for those who love the wind in their face and an open road ahead.

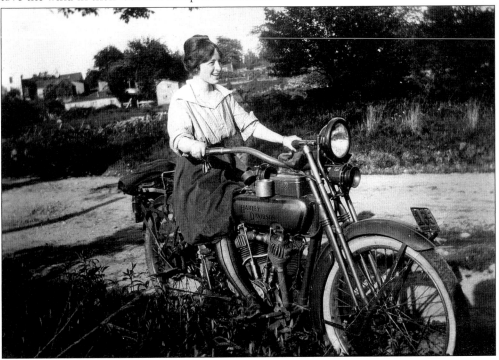

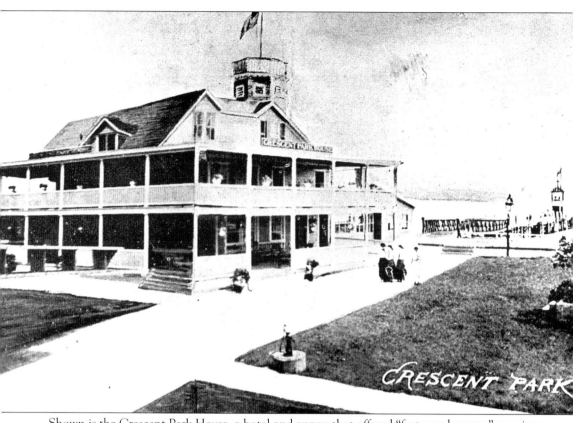

Shown is the Crescent Park House, a hotel and annex that offered "forty cool rooms," a casino, bowling alleys, bathing, boating, and fishing for $10 a day or $12 a week. This is now the site of Niantic Yacht Club.

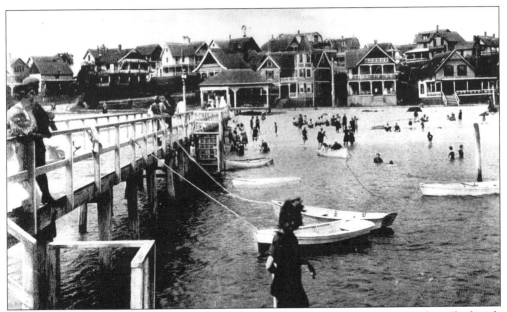

This view shows people bathing at Crescent Beach in Niantic on a hot summer day. The beach was developed by Capt. James V. Luce in the 1880s. He built White Beach House, which was famous for shore dinners.

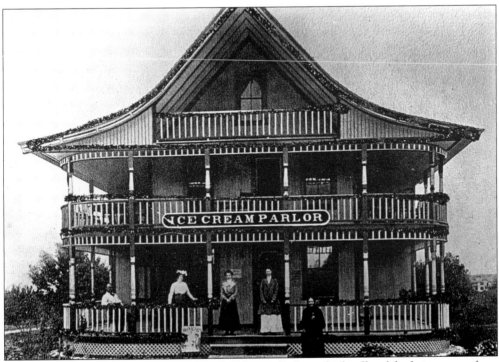

A must at Crescent Beach was Caroley's Ice Cream Parlor, which offered fresh ice cream from local farm creameries. Today, the closest comparable parlor is in Salem near Route 2.

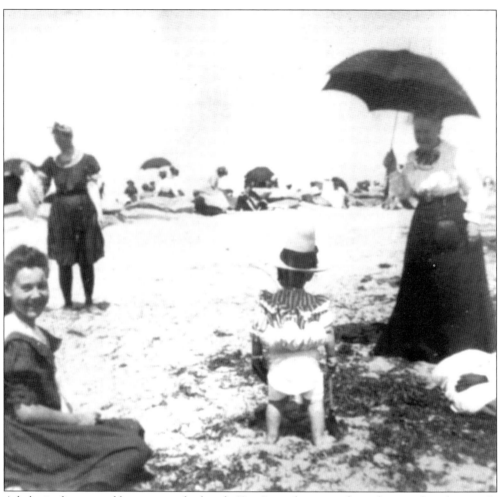

A baby in diapers and hat surveys the beach. East Lyme has gone through several evolutions. It has been part of New London, Lyme, and Waterford without ever really changing its personality, mainly because it is made up of groups who settled here at different times in history. Fishing, farming, shipbuilding, weaving, granite works, military camps, shopping areas, Spiritualist camps, average summer people, wealthy summer people, and bedroom communities for major corporations—all have contributed to the mix. The main ingredient was and still is the place.

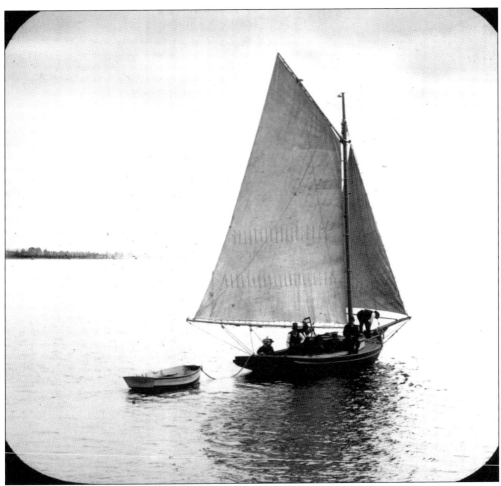

The water is always slightly warmer and less turbulent on this stretch of the coast because of protection from Long Island, just 13 miles away by boat. Everything from an old rowboat to a huge yacht can be seen going by on a summer day.

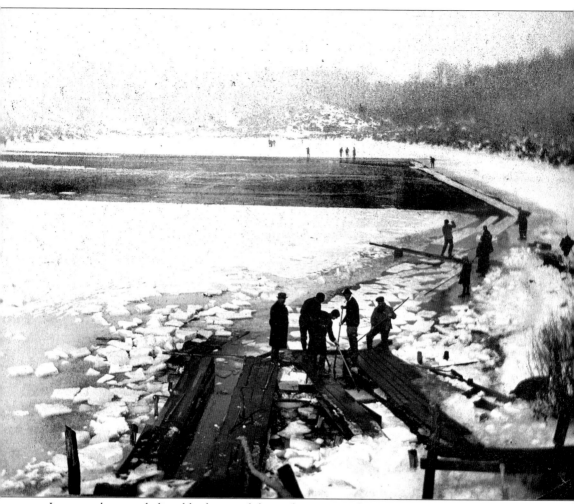

It seems almost unbelievable that ice did not always come from refrigerator trays or icemakers, but so it was until well into the 1900s. Cutting ice was big business here and in other places along the coast, providing restaurants and other wholesalers with a way to keep food fresh. Ice was cut primarily on Dodge Pond but also on other ponds. The harvesting required a team effort; it was both exhausting and dangerous in the harsh winter. On the pond site, the slabs were cut and then prodded onto a wooden sluiceway.

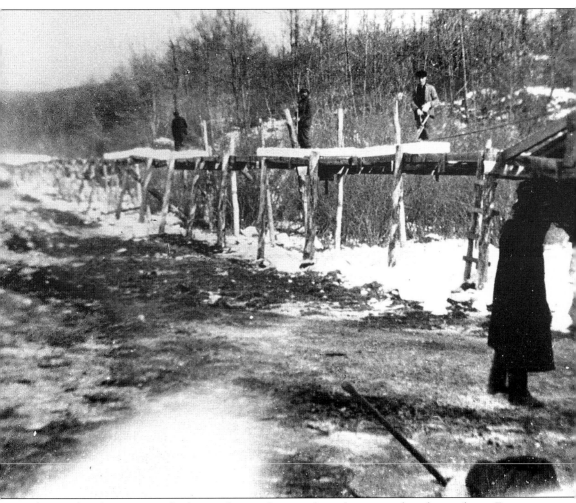

The wooden sluiceway was built on a slope with stops along the way to slow the ice down. From here, oxen moved the blocks of ice to the icehouses at the depot.

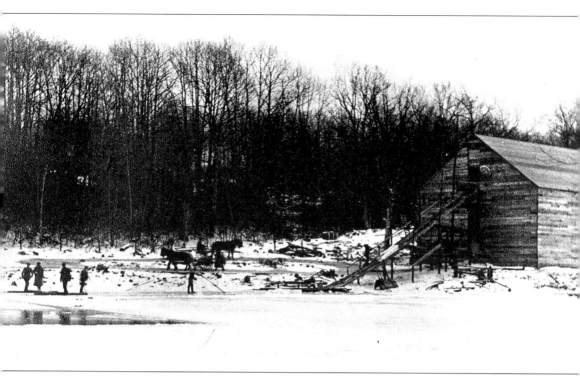

At the depot the blocks were stacked in rows, with sawdust between rows as insulation to keep the ice frozen. The ice was used for packing fresh fish destined for stores and restaurants in New York, Boston, and other places in between.

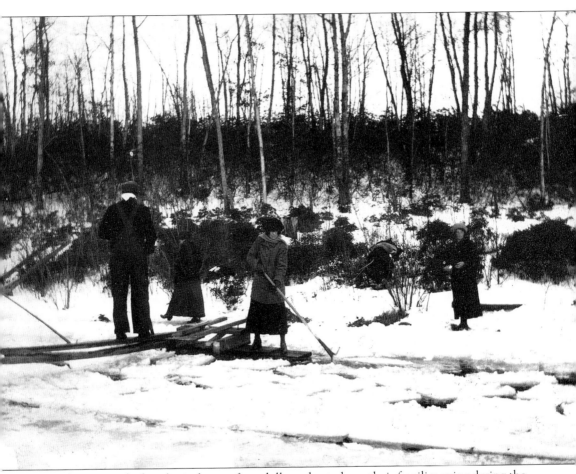

Many farmers worked at the icehouses for a dollar a day to keep their families going during the winter. When the old icehouse (above) was disassembled, a section of it was moved and attached to the west side of Niantic House, where many fishing families lived. Two families, the Havens and the Avery Smiths, were prominent in the ice business, which provided a way to keep fish fresh on its journey to coastal cities.

In the mid-1930s, the *New London Day* described the growth and commercial development of downtown Niantic: "Main Street has taken on a metropolitan appearance, with substantial modern business buildings that would well befit a place much larger." A new library, post office, hall of records, and community center were all accomplished within 15 years. Business kept up, with a renovation for the Morton House, the Connecticut Light and Power offices, and the expansion of Hilliar's as a hardware store and service station. Niantic Lumber's advertisements said, "Phone 56."

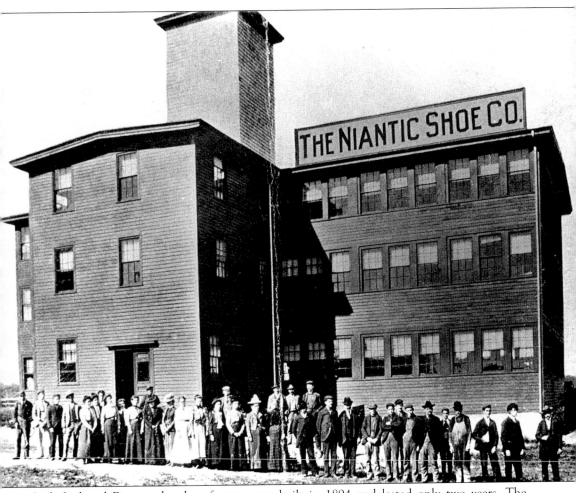

Lightford and Finney, the shoe factory, was built in 1894 and lasted only two years. The building later became a fruit extract factory, which also lasted only two years. The site then was operated as Laskar and Brown Typewriters, before it was used to manufacture gun cotton in World War I.

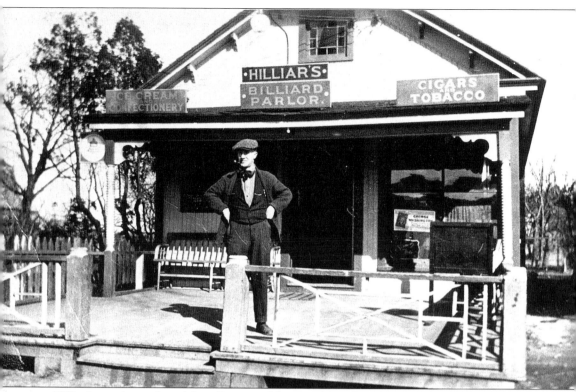

Hilliar's was located on Main Street in Niantic. According to a 1930s edition of the *New London Day*, the store and service station was "very up to date." It featured a billiard parlor and offered ice cream, candy, cigars, and tobacco.

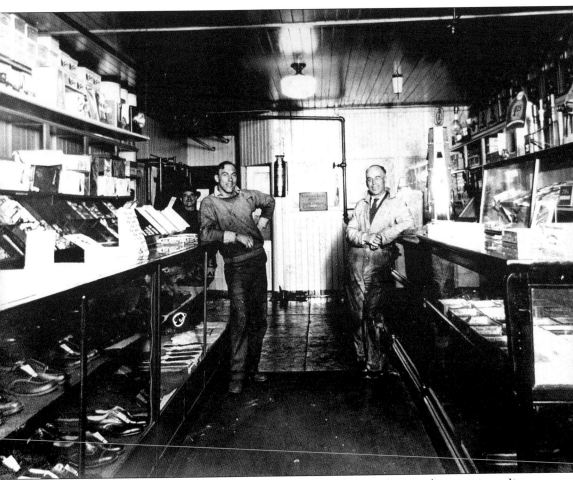

This interior view of Hilliar's shows that everything was sold here, from to shoes to cigars. Jim Perkins is the second person from the left.

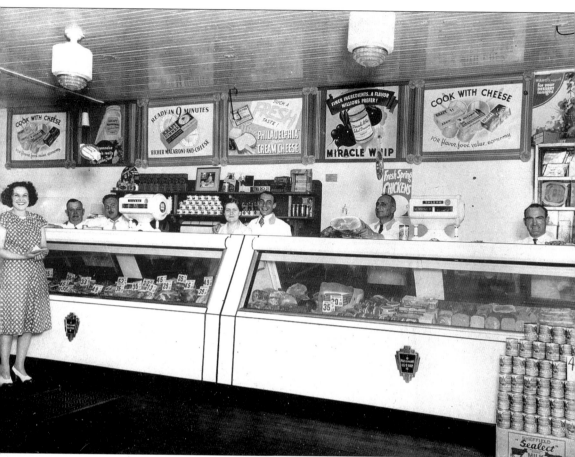

Pete Mitchell (center) stands behind the counter in his store. The market was a very popular place. Mitchell's sons made deliveries by bicycle to residents as far as away as Old Black Point. The Mitchell boys grew up to be successful and prominent members of the community. Andrea Chapman (left) served as town tax collector for many years and owned the Pennsylvania Avenue property developed as Chapman Farms. Notice the prices on the posters—aah, those were the days.

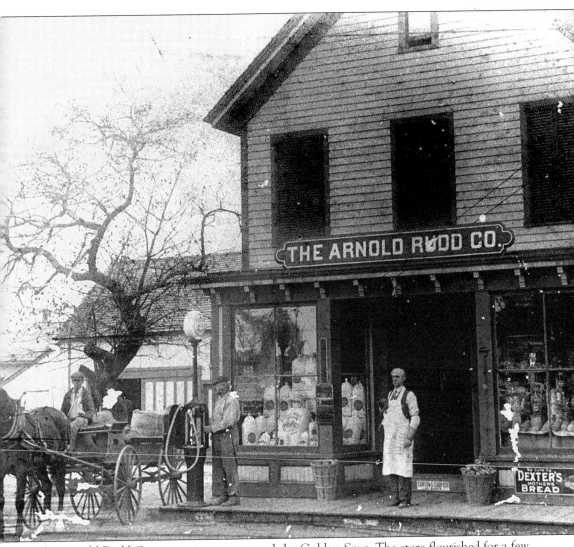

The Arnold Rudd Company store was named the Golden Spur. The store flourished for a few years and then waned as the automobile became popular. The Golden Spur was originally named by Walter R. Denison of Groton in 1906.

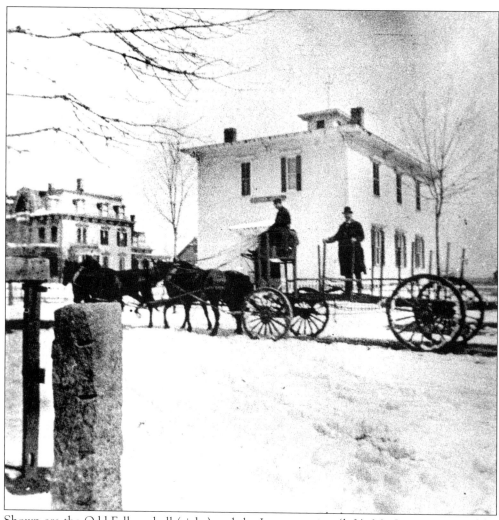

Shown are the Odd Fellows hall (right) and the Luce mansion (left). Mr. Luce was a wealthy man with various business interests locally.

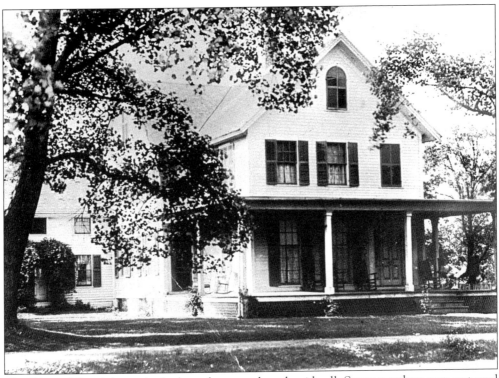

The Edmund Smith house had a large front porch and a side ell. Street numbers were not used until fire regulations were adopted.

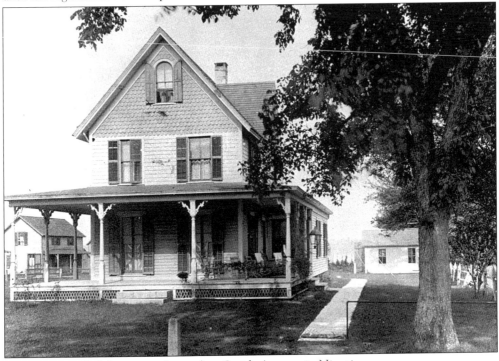

The Captain Clark house was located on Smith Avenue in Niantic.

Arthur Beebe enjoys a day at Bride's Lake.

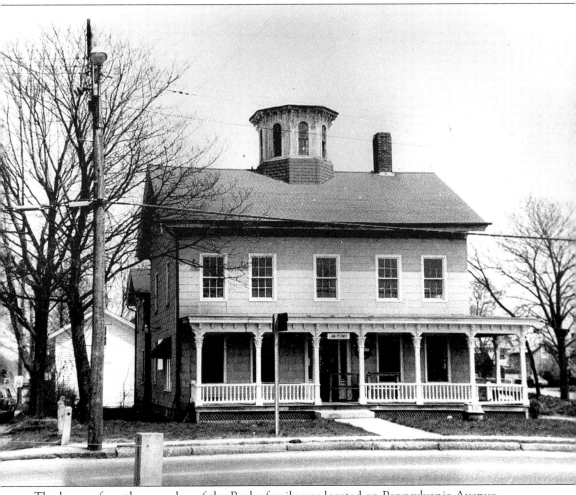

The home of another member of the Beebe family was located on Pennsylvania Avenue.

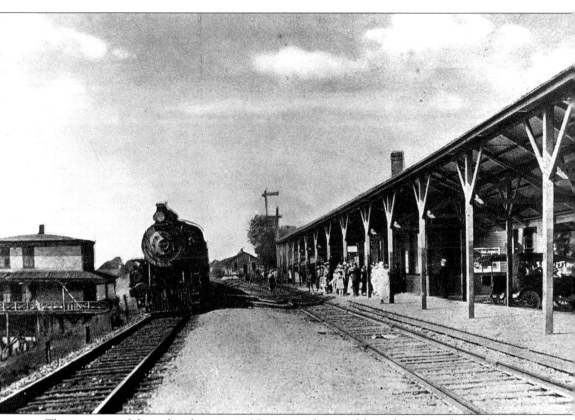

This is a view of the railroad station in Niantic, with a northbound train on the track.

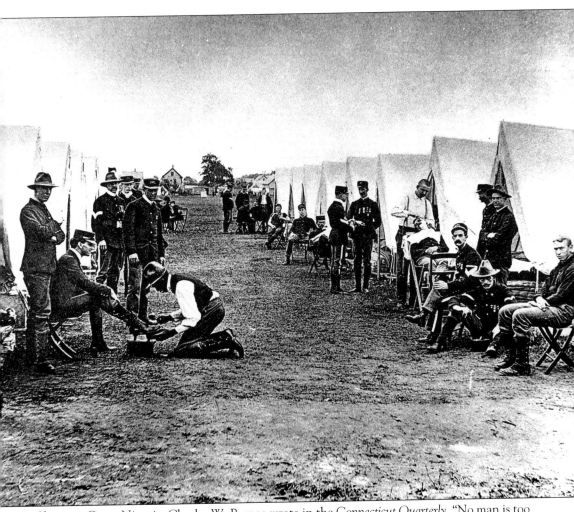

Shown is Camp Niantic. Charles W. Burpee wrote in the *Connecticut Quarterly*, "No man is too high born to feel out of place in the ranks and no man is too humble of origin to fail of promotion if he deserves it. The rank and file demand that the honor of the organization be maintained." So it was, and so it continues to be.

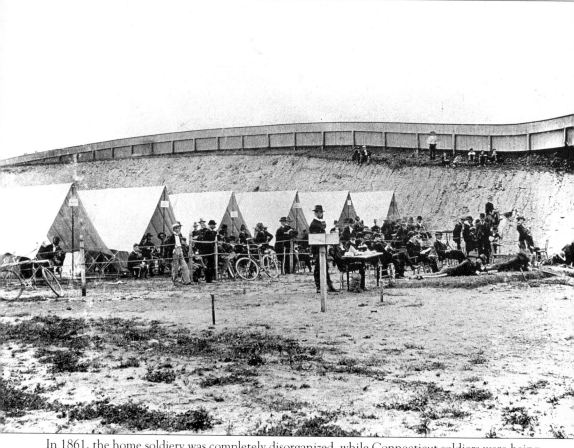

In 1861, the home soldiery was completely disorganized, while Connecticut soldiers were being killed in the Southern states. The citizens of Connecticut rallied, and the militia became the Connecticut National Guard. Its 4,141 men made up two brigades. Thus, Camp Niantic began.

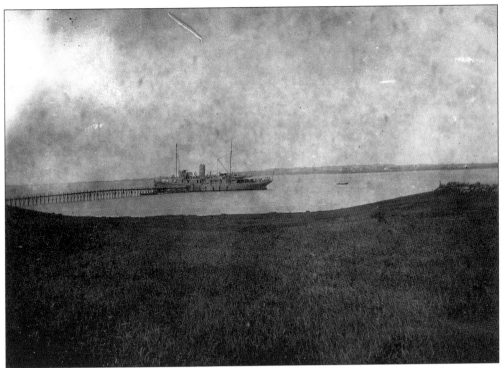

America joined the Allies and declared war in 1917. By mid-September, troops from Camp Niantic were headed to France. Many did not return.

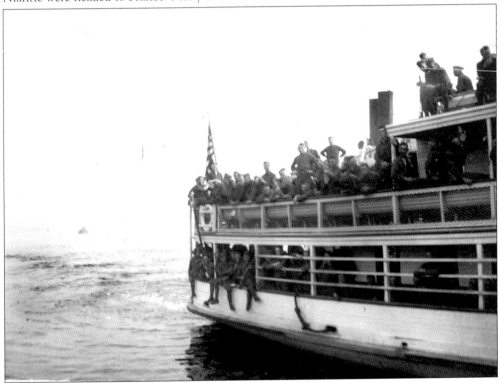

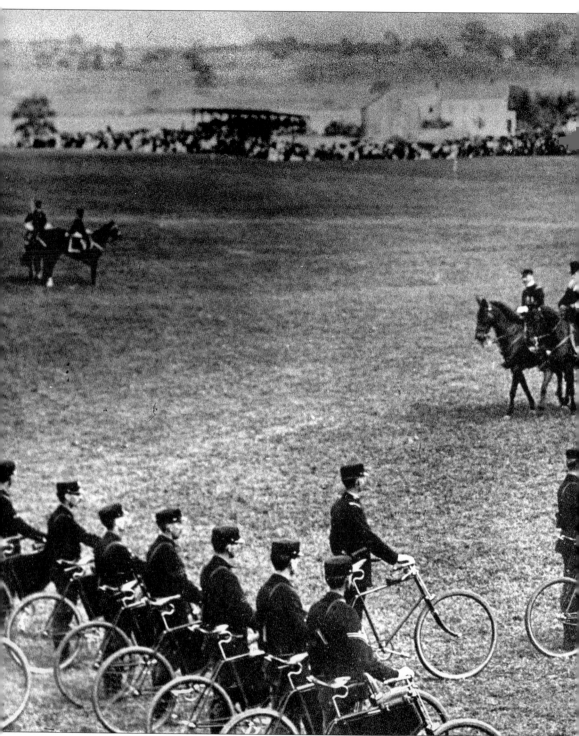

In 1877, Camp Niantic was formed on a leased tract of land that could hold the entire brigade for annual encampments. It proved so successful in its mission that, in 1881, money was appropriated to purchase 65 acres to be used as a permanent campground. The final cost was

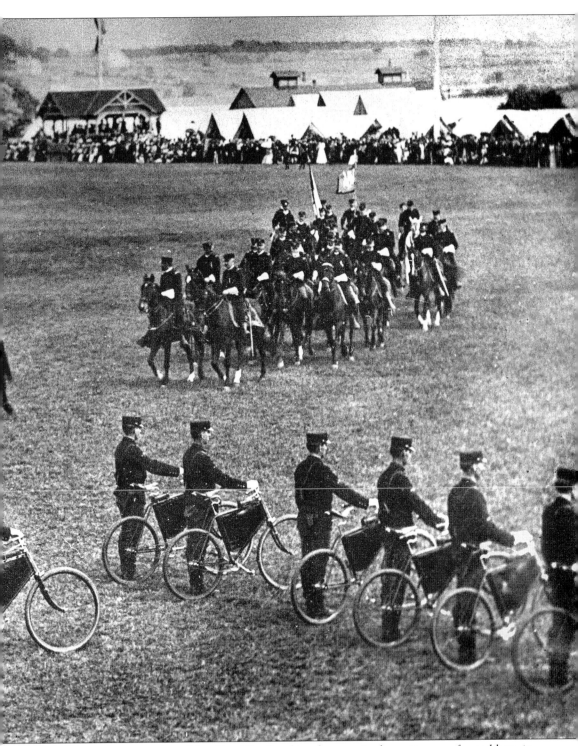

$18,500, paid to a number of families. The first bicycle corps in the nation was formed here in 1891. Here, Gov. Simeon E. Baldwin reviews the corps during the annual event.

A member of the Peck family flies the colors on April 17, 1917. This was to be "the war to end all wars."

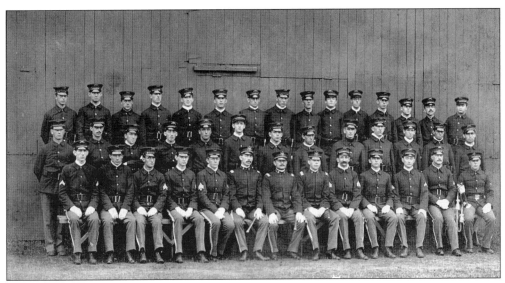

In 1912, the brigade exercise simulated an attack and defense of New York City. In 1916, the brigade served in Nogales, Arizona, against Poncho Villa.

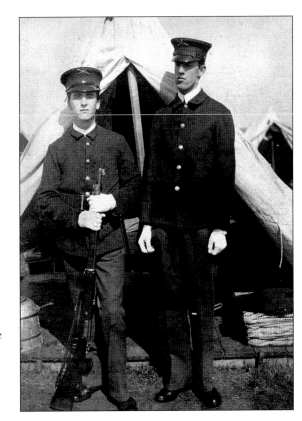

Camp Niantic remains to this day an essential training ground in the state. The uniformed young people continue to take their jobs seriously, and women now are as likely to be in command as men. The community is proud of them and thankful for their service to the country.

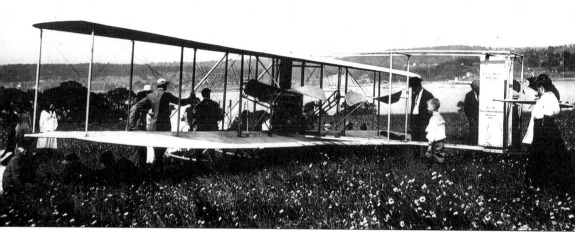

Shown is a landing at Camp Niantic. Planes were still an oddity that amazed and excited curious children and adults. The camp's position on the coast made it an excellent destination. The landing field at Stone's Ranch, off Boston Post Road in Flanders, was also used.

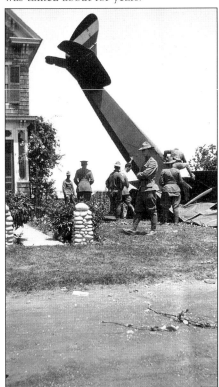

Not all landings were quite successful. Living near the base had its risks, as this scene shows. Luckily, no one was hurt. The homeowner, Fire Chief Legrand J. Hall, would have been ready. His daughter, Elizabeth Kuchta, said the accident was headline news in the paper and was talked about for years.

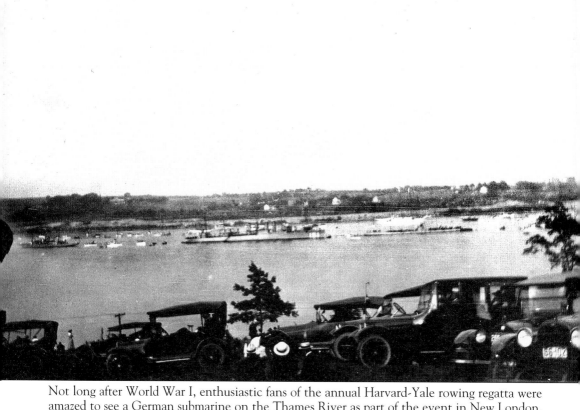

Not long after World War I, enthusiastic fans of the annual Harvard-Yale rowing regatta were amazed to see a German submarine on the Thames River as part of the event in New London. Many people from East Lyme attended the event, and the Fred Beckwith family brought back this remarkable photograph. The sight must have given pause to many who saw that vessel in that place at that time.

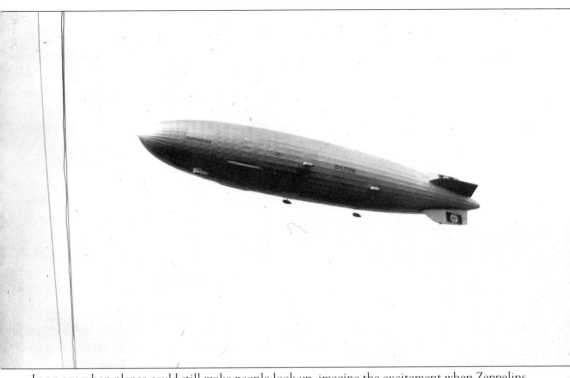

In an age when planes could still make people look up, imagine the excitement when Zeppelins first appeared in our sky. This, the *Hindenburg*, was to gain fame through its destruction in an accident carried live on the radio on May 6, 1937. It is thought that a spark from a metal guy rope ignited the helium. Thirty people died. Capt. Charles Lindbergh flew his plane, the *Spirit of St. Louis*, over East Lyme and landed at Camp Niantic.

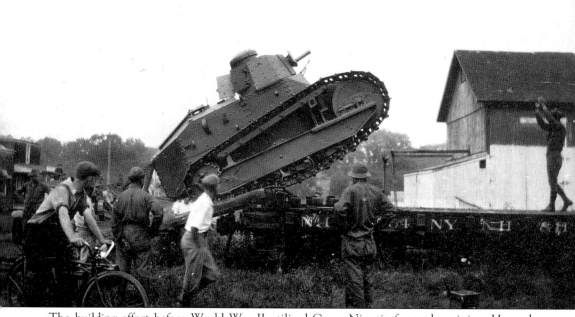

The building effort before World War II utilized Camp Niantic for tank training. Here, the vehicles are unloaded from railroad cars prior to being moved on site.

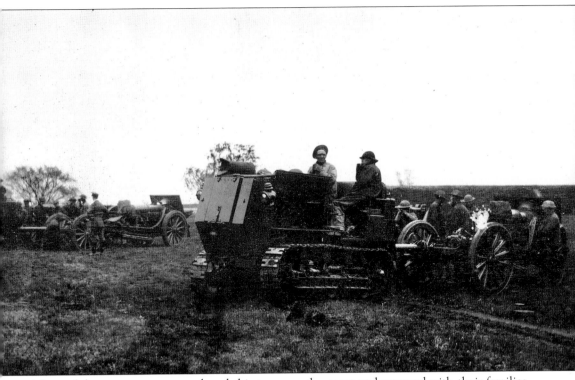

Many of the young men remembered this town on the coast and returned with their families after the war.

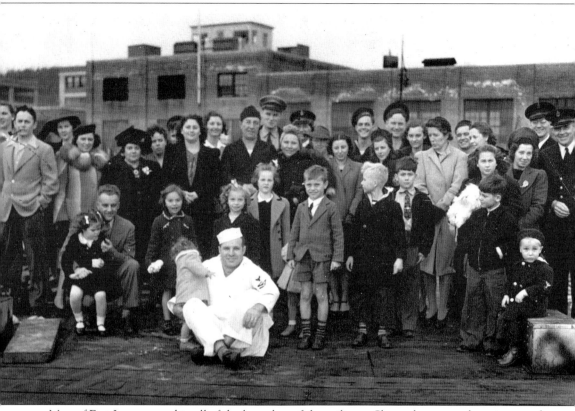

Men of East Lyme served in all of the branches of the military. Shown here are submariners and their families. Both the Electric Boat division of General Dynamics and the U.S. Navy base in Groton brought people from all over the country. It was the only submarine base on the east coast. Chief Murray Flanders of Niantic is at the far right. His family stayed on in the area after the war.

ACKNOWLEDGMENTS

Thanks are due to the generous people who provided their personal collections of photographs and information for this book: Ron Martel at Magic Wand, Elizabeth Hall Kuchta, William O. Manwaring, Norman Peck, Denise Russo, Flora Storrs, Ed Tverdak, Eleanor Yuhas, Nancy Foster, Mrs. Ford, and all of those those at the Smith-Harris House and the East Lyme Historical Society.

BIBLIOGRAPHY

Chendali, Olive Tubbs. *East Lyme: Our Town and How It Grew*. 1989.
Coffin, Charles C. *Old Times in the Colonies*. 1881.
Harding, James E. *Lyme Yesterdays*. 1967.
James, May Hall. *Educational History of Old Lyme*. 1939.
Lodge, Henry Cabot. *English Colonies in America*. 1881.
New England Historical and Genealogical Society. Register, vol. LXXIX. January1925.
New England Historical Genealogical Record. Lyme Burying Ground Records.
New London County Historical Society, Records and Papers V, vol. I.
Prendergast, William J. *Exploring Connecticut*. 1965.
Scott, Wilfrid. *Whistletown Wilds*. 1966.
Singleton, Esther. *Social New York Under the Georges*. 1902.
Tales of Bygone New England. 1988.
"Tales of the New England Coast," *New England Magazine*. 1985.
Van Dusen, Alert E. *Revolution to Constitution*. 1975.

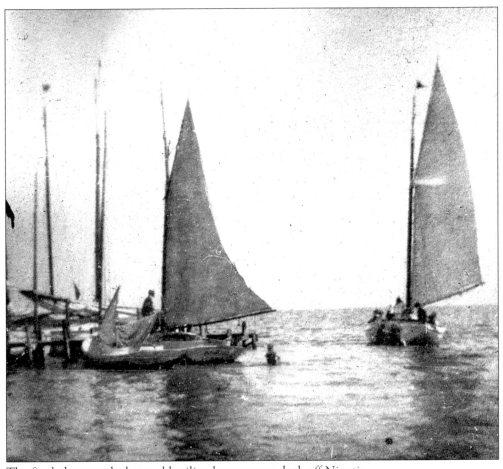

The final photograph shows old sailing boats near a dock off Niantic.